JAPANESE FOLK TOYS

JAPANESE FOLK TOYS

THE PLAYFUL ARTS

LEA BATEN

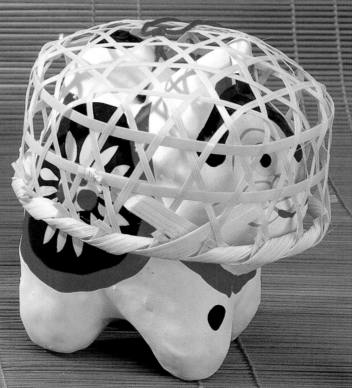

SHUFUNOTOMO CO., LTD.

Photography: Herman Van Hoey and Eugeen Vangroenweghe
of
Verne Studio

Book design: Toshiaki Suzuki

First printing, 1992

Published by Shufunotomo Co., Ltd.
2-9, Kanda Surugadai, Chiyoda-ku
Tokyo, 101 Japan

Printed in Japan

ISBN4-07-975612-7

To my grandchildren Jade and Jean-Christophe,

may they see life with wisdom, humor, courage and compassion…

and understand that all true living is a game that must be played

according to the rules of the heart.

Suddenly it becomes important to decide what is a toy...

It is a substitute for which there is no substitute.

It exists for its own sake and yet it should be somehow unfinished.

It shouldn't be designed to teach, yet it should help you to learn.

ALAN BRIEN,

New York Times, January 12, 1970.

IN GRATITUDE

My gratitude goes to all the people involved in the creation of this book, in particular to my family and friends, whose support and understanding made my writing possible.

An art book without visual joy is not a complete experience, and my sincere thanks are due to my photographers Herman Van Hoey and Eugeen Vangroenweghe for the flair and impeccable taste with which they translated the elusive charm of simple toys into beautiful graphics.

My thanks and appreciation also go
–To Shunichi Kamiya, general manager of Shufunotomo's International Department, who is gifted with patience, competence, psychology, and the love of his work.
–To Kosei Yamasaki, patient maker of Karakuri dolls, for answering questions, sending illustrative material, and especially for his precious gift of the book "Edo Nishiki" which proved of great benefit in situating toys in time and place.
–To Tokubei Yamada, 11th generation doll and toymaker, president of Yoshitoku Toys, for his clear-cut information.
–To Wendy Makino and Nariaki Suzuki, dear friends of long standing who were always ready to help with word and deed.
–To Akiko Oe for her gift of some rare items.
–To Mary and Jack Hillier for their friendly assistance.
–To Gregory Irvine of the British Museum for his attempt to trace the enigmatic dolls of Lafcadio Hearn.
–To Harumi Yoshizawa and Yashiko Keene for selling…and telling the stories of many little toys.

It was hard work, but it was great fun!

CONTENTS

INTRODUCTION

When is a folk toy not a folk toy?

This is not a Zen riddle but a question with an easy answer: when it is Japanese.

Although known as folk "toys," many do not really fit the conventional definition of "plaything." Children of a bygone age *could* play with them, but play was not, in general, their primary purpose. Their role extended to include serving as amulets, souvenirs, and lucky charms, capable of granting wishes and averting all kinds of evil. Fulfilling the playful needs of adults, who have as their only excuse that they are grown-up children, is as often their function as creating that wonderful world of make-believe which gives joy to the younger generation. The rich symbolism and magical meaning attached to folk toys in Japan are not strange in a country where the strong underlying current of Shinto animism still pervades many aspects of daily life. The earth, trees, and plants are all considered to be the homes of gods or *kami*, and when used in the form of clay, wood, or straw figures, these materials are representatives of the deities and are believed to be highly imbued with their protective and curative powers. Dolls and toys made in human or animal shapes were thought to possess a spiritual life of their own.

Turning back the pages of Japan's figurative tradition, it is the clay doll that has the oldest history, dating back 10,000 years to the strange *dogu* figurine of the neolithic Jomon period. The eyes of these hand-formed statuettes, known as "insect" or "owl" eyes, are distinctive. Later, large eyes and a fierce expression were found on many folk toys and were considered to be specially potent in warding off evil. These ancient female figures formed a link between gods and men, for the *dogu* was presumably buried as a gift to the spirit of the earth as a plea for universal fertility. That prayer still echoes today, for many toy-fetishes exist whose purpose is to give fertility to human beings, animals, and land.

In the Kofun, or Tumulus, period we again meet with clay figures invested with guardian and protective duties: the *haniwa* statuettes of human beings and animals. These evolved from the plain clay cylinders placed around mound-shaped tombs. The "Nihon Shoki" chronicles of Japan, written in AD 720, tell us that in AD 3, during the reign of the Emperor Suinin, the clay figures were substituted for the sacrifices of humans and animals on the grave of their master. Many subjects from everyday life are recurring motifs in Japanese arts and crafts. The hunters, dancers, horses, dogs, monkeys, barnyard fowl, wild animals, and birds of antiquity are still the inspiration for contemporary toys.

The Asuka period brought the introduction of Buddhism and the practice of cremation, used not only for human beings, but, in later ages, for dolls and toys which had acquired a "spirit" by being played with, or had become impure by absorbing illness. The present custom of burning old playthings at temples and shrines surely owes something to this belief, for to burn the toy was to destroy the evil it may have contained.

Korean immigrants who came to Japan in the wake of Buddhism brought many innovations from the mainland, among others, the calendar and the oriental zodiac with its twelve different animal signs. Weaving and papermaking contributed the basic materials for paper and papier-mâché dolls and dolls' clothes.

A kind of football (*kemari*) was introduced from China, and it became a favorite court game, many emperors becoming quite

expert. There also came a treasury of Chinese festivals, legends, superstitions, and symbols, which were quickly adapted and assimilated into Shinto and Buddhist rituals.

From the Nara period there is evidence of the two oldest existing amulet-toys of Japan: the flat wooden horse made at the Tamukeyama Hachiman Shrine by Shinto priests, and Empress Komyo's tiny dog charms made at Hokke-ji Temple by Buddhist nuns. As witnesses of the continuity of Japanese tradition, these two toys are still being made today at their places of origin in Nara City.

The Heian period saw the birth of two literary masterpieces: "The Tale of Genji" by Murasaki Shikibu, and Sei Shonagon's "Pillow Book." Both contain descriptions of dolls, dolls' houses, and the Doll Festival or *Hina Asobi*. The two books give many interesting descriptions of Heian life and customs, but it was the life of the elite, the emperor and his courtiers.

Hagoita (battledores), a Chinese import, appear to have been popular, both as playthings and exorcism charms, and have kept their original shape to this day. Puppetry and many kinds of paper, textile, and wooden dolls and toys appeared during the Heian period; they were used for play, as amulets, and for divination. Handball (*temari*) played with balls of silk strings wound in pretty patterns was popular with young girls.

Although the Kamakura period was an era of militarism and Zen austerity, there was one intriguing development which seems to be a unique and fragile link between religious sculptures and dressed dolls. Nude and semi-nude wooden figures were made and their clothes donated by believers. The statues are extremely rare and not many have survived; the custom of giving clothes to sculptured images, however, is still popu-

lar and can be seen in many graveyards and temple gardens where *jizo* images wear red bibs and caps. The oldest known sculpture of *daruma*, in Empuku-ji Temple near Kyoto, dates from the 13th century. As Zen Buddhism became popular at this time, it is possible that the first *daruma* dolls date from this period. The custom of painting in a second eye on a *daruma* toy in exchange for a granted wish is basically a religious practice. For a new Buddhist statue the most important event was the "opening of the eyes" ceremony, when the eyes were painted in or unveiled; only then was it truly sacred and "alive" to prayers.

The Muromachi period was a time when both court and shogun attached great importance to aesthetic pursuits. The tea ceremony and the noh theater were the preferred pastimes of the elite. As the noh theater originated in Nara, the famous Nara dolls, representing actors wearing their beautiful brocade robes and splendid wooden masks, later became the typical toy of Nara City. Lafcadio Hearn mentions an intriguing doll, the Kirabuko or Jolly Old Boy, made for the Emperor Gomizunoo; it slept on the emperor's own pillow. It is said that a copy of it "healed sick people by producing laughter."

The Momoyama period was the age of castle-building and baroque splendor. Shinto shrines and Buddhist temples played an important role in the production and distribution of toy-amulets and charms. Like the medals, relics, and pious images of the west, they had luck-bringing and protective qualities. Travel was under strict surveillance, but exceptions were made for pilgrims fulfilling some vow, such as visiting the Great Shrine of Ise or 33 Kannon temples. In poor villages pilgrimages were a once-in-a-lifetime affair, and it was an accepted practice for all the

people to save money until a sufficient amount had been gathered, and then hold a lottery to designate a few lucky ones who had the duty of conveying prayers and pleas to the deities, and of bringing back sufficient lucky toy-amulets for the whole village. The custom of *omiyage*, buying a small souvenir for friends and family when one travels, still exists.

The festivals at shrines and temples were often the excuse for travel and jollity, and inspired many toys representing some edifying aspect of an ancient legend or some miraculous event which had occurred at a sanctuary. The Mayumi horse and the owl of Zoshigaya are examples. Many rituals and sales were held at the time of the new year. As the amulets had lost their protective power after having absorbed the evil of the past year, they were brought back to be burned and replaced by new ones. This was, of course, a commercial ploy of the priests, with which the people played along.

Edo, the capital of the Tokugawa shoguns, was the heartland of a new commercial and cultural era. When the economy, based on rice exchange, turned to one of hard currency, it was only normal that those with money to spend should visit the kabuki theater, the bunraku puppet shows and the Yoshiwara pleasure quarter with its beautiful courtesans. It was natural to spend liberally on art, dress, amusement... and even dolls and toys. The dolls must have been particularly lavish, for the Shogun Yoshimune, who had curious ideas for saving money, issued a sumptuary edict forbidding dolls of more than 20 centimeters to be made. Wise dollmakers took revenge by making exquisite miniatures with costly materials, which were even more expensive than large dolls. For toymakers it was a prosperous time; the woodblock-printed

book "Edo Nishiki" of 1773, designed by the great artist Kitao Shigemasa (1739-1820) shows more than 80 different dolls and toys, and it is probable that more than 300 kinds were being made by 1804. Not only static toys were made, but a variety of simple mechanical devices were added to give the miniatures mobile interest.

Local shrines and temples had their share of the general affluence, and many Tokyo sanctuaries still sell the toy-amulets and lucky charms popular in the effervescent Edo era. The daimyo or noblemen visiting the capital saw the lucrative possibilities of toymaking for their districts, and more than one took home an Edo craftsman to teach the people of a distant province the secrets of his craft.

The Edo period provides many interesting views on contemporary life in the form of woodblock prints, illustrated books, and articles for everyday use. Popular dolls and toys were often used as decorative motifs on clothes, porcelain, pouch clasps, lacquered boxes, and *inro*. Miniature playthings were carved from wood or ivory to be used as *netsuke*, an innocent looking doll sometimes hiding erotic happenings under a flowing robe or in a small box. There is also an interesting Harunobu (1725-1770) set of five woodblock-printed books, *Ehon Seiro Bijin Awase*, "Picture Book Comparing Beauties of the Green Houses," showing the pastimes of pretty courtesans during the four seasons. The prints seem to prove that young girls of the pleasure district spent a good deal of their time in genteel occupations: dressing dolls, playing with the *hagoita*, winding patterned thread balls, and playing cards and the shell game.

At times, even woodblock prints were "dressed," for the Musées Royaux d'Art et d'Histoire, Brussels, have a unique series of

high-quality prints, made between 1765 and 1775, of which parts have been cut out and replaced by textiles. One represents a doll-like child with a box containing two hand puppets (cymbal players), holding up a furry animal toy, represented in "Edo Nishiki." Puppetry was popular; puppeteers ranged from itinerant peddlers who visited fairs and isolated villages, to famous artists who were summoned to the castles of lords and the houses of rich merchants. Amusement for the masses was provided by the puppets of the bunraku theater.

The *karakuri* or trick dolls, ingenious automatons moved by a variety of intricate mechanisms, were made for the amusement of the rich. The *Karakuri Zue* or "Collection of Mechanical Designs," printed in 1796, gives examples of such toys and detailed instructions for making them. One of the most remarkable models shown in this book is undoubtedly the *chahakobi ningyo* or tea-serving doll, which walked to a guest with a cup of tea, stopped when the cup was lifted, and returned to the sender when the empty cup was replaced. The many mobile toys of central Japan reflect the *karakuri* puppet shows given at local festivals. They were specially interesting because the manipulators were hidden inside beautifully decorated floats, working in teams and moving large puppets by means of rods and cables. Some small automatons were made as simple imitations of these costly wonders.

The great Tokaido Road between Edo, the shogunal capital, and Kyoto, the imperial capital, made communication, pilgrimages, and cultural exchanges easier. Kyoto was primarily known for its more sophisticated dolls: the Gosho, Saga, Kamo, *hina*, and the rustic clay doll of Fushimi. In "Five Women Who Loved Love" the daring writer of the time, Ihara Saikaku, nostalgically describes the articles at a roadside souvenir-and-tea shop:

> On a side counter were tea brushes, clay dolls, and dancing drummer dolls... reminiscent of Kyoto and therefore a tonic to the weary travelers who rested there awhile.

Far from Edo, the climate, materials, and husbandry of a district were reflected in regional toys. The northern regions where horses were raised and wood was plentiful, gave a multitude of lathe-turned *kokeshi* dolls and roughly cut, colorful horses. The *inau* ritual implements of the Ainu people of Hokkaido influenced the delicately curved wing and tail feathers of the Sasano birds. The south was undoubtedly influenced by China-via-Korea imports, as seen in the more sophisticated pottery and porcelain figurines; the oriental zodiac, which was the inspiration for many exotic animal toys; and the many pull-toys that had wheels.

The *namban* or southern barbarians, more particularly the Dutch and Chinese, were represented by the clay Koga dolls of Nagasaki. Certain mother and child toys are thought to be secret versions of the Virgin Mary and Jesus made during the persecution of Christianity. That Zen Buddhism made a lasting impression on Japan is proved by the many versions of *daruma*, the lovable and humorous little roly-poly toy found throughout the country.

The materials were preferably cheap or even free: clay, wood, bamboo, straw, grass, vine, old paper, represented the most often used basics for folk toys, and it was left to the imagination and inventiveness of the craftsmen to create original and appealing playthings... and as everyone loves a story, many true and untrue tales were told to stimulate business. Potters and tilemakers made ceramic statuettes, joiners and

carpenters carved birds and animals from their waste wood, fisherwomen made figurines from shells and other marine materials. In poor country districts toymaking was usually a cottage industry, meant to supplement the income of farmers in the dead season. The toys were collected by wholesalers and taken to towns and cities where many people gathered for markets and religious festivals.

In 1854 Commodore Matthew Perry forced Japan to open certain ports to foreigners. The Shogunate was abolished, and in 1868 the "enlightened rule" of the Meiji Emperor began. Folk toys of the time were originated by impoverished samurai who no longer had a master to pay them. The little black Kobe automaton with banjo or melon was inspired by black sailors disembarking at the newly opened port of Kobe. For toys too, a new era began, for as proof of the superiority of western nations, Perry had brought a small-scale train to Japan as a present for the Emperor.

Happily, various folk toys still survive in their primary form. Some disappeared when their maker died, but were revived many years later to meet the renewed interest of collectors or the demand of the tourist trade. A small number stayed exactly true to type through the ages, while others were commercially "modernized" and came to bear almost no resemblance to the originals.

A happy few have been adapted to changing times with taste, intelligence, and above all, without concessions to the ancient standards of excellence. Some are irrevocably lost. The true folk toy is in need of protection, and the particular techniques of certain doll and toy types have recently been designated by the government as Intangible Cultural Assets. Folk toys representing the zodiac animal of the year are often shown on postage stamps, as an effort to save regional toys and revive public interest in them. While these are praiseworthy initiatives, they can hardly stop the artisan who finds joy in working with his hands from getting older, and the natural materials needed for specific toys from getting scarcer. The people who know the finer points and quirks, the meaning of the humorous details behind the unassuming aspects, are quietly fading into the past.

And yet it is the folkcraft that is the strong undercurrent of a people's culture and civilization, the underlying power that gives form to the beliefs, hopes, and prayers of a nation. In the honest little toy, that never pretends to be better than it is, the age-old conventions are always observed, and symbolic values still hold true. The color red scares away evil spirits, or attracts and absorbs them. Large eyes and a menacing expression keep evil at bay. Monkey and horse are fertility symbols. A dog amulet protects and gives easy childbirth. A *daruma* will grant a wish in exchange for his second eye. Specific toy-amulets protect against hysteria, melon thieves, fire, clogged noses, earthquakes. Others give health, wealth, happiness, safe journeys, luck in business, good marriage partners, abundant silkworm harvests... although the luck is valid only for one year.

Can any modern toy boast so many advantages for such a modest sum?

While some toys are found throughout Japan, many are specialties of a particular prefecture, town, or temple. Certain traditional toys can be bought at craft shops and prefectural showrooms, and with luck and patience, older toys can sometimes be found at antique shops or street markets. Religious amulets are sold only in limited quantities at their place of origin or during an annual festival, usually at the beginning of the year when fresh luck is wanted.

Hokkaido and Tohoku District

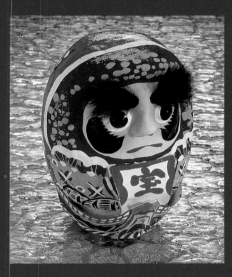
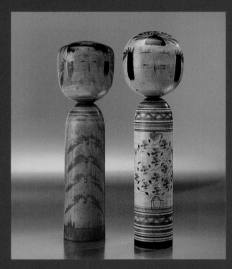
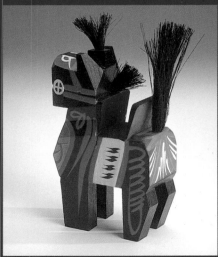
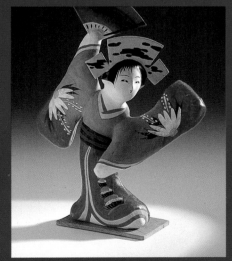

Prefectures of

AKITA	**IWATE**
AOMORI	**MIYAGI**
FUKUSHIMA	**YAMAGATA**

AINU DOLLS

AINU NINGYO

WOOD

HOKKAIDO

Hokkaido, the Great North of Japan, is the homeland of the Ainu, the mysterious aboriginal inhabitants of the Japanese islands. The enigma of their origin and language has never been satisfactorily explained; like the American Indians, they are nearly extinct, only an estimated 300 pure Ainu remaining in 1971. Known in the old chronicles of Japan as the Ezo or Yezo people, the male population's custom of letting hair, beard, and mustache grow, gave them the name of "hairy" Ainu, while the women's custom of tattooing lips and forearms, to prevent evil spirits entering the body, was forbidden at the Meiji restoration. A unique transport system consisted of supporting weights carried on the back by forehead bands as seen in other countries far from Japan. Salmon fishing, bear hunting, and the strange and terrible bear ceremonies (*iomandé*), are responsible for the many depictions of bears with and without salmon, which have become the standard souvenirs of Hokkaido. Although handwork is still produced, it is clear that the small number of native Ainu cannot cater to the impressive tourist trade and produce the great quantities of woodwork offered for sale. Quality varies enormously, but in general, the commercialized crafts of Hokkaido are only a pale reflection of the Ainu people and their way of life, forever lost.

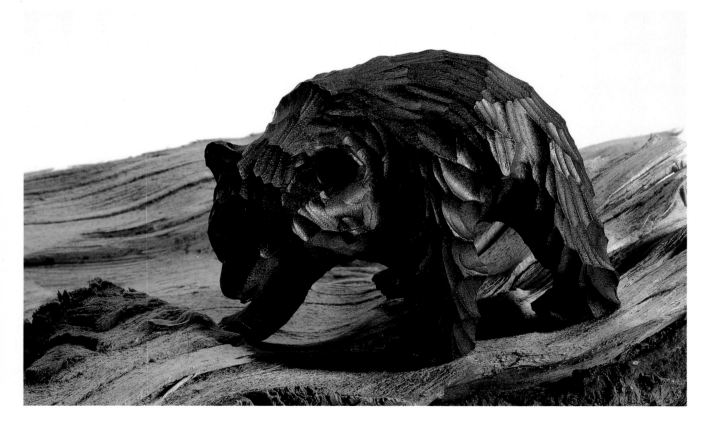

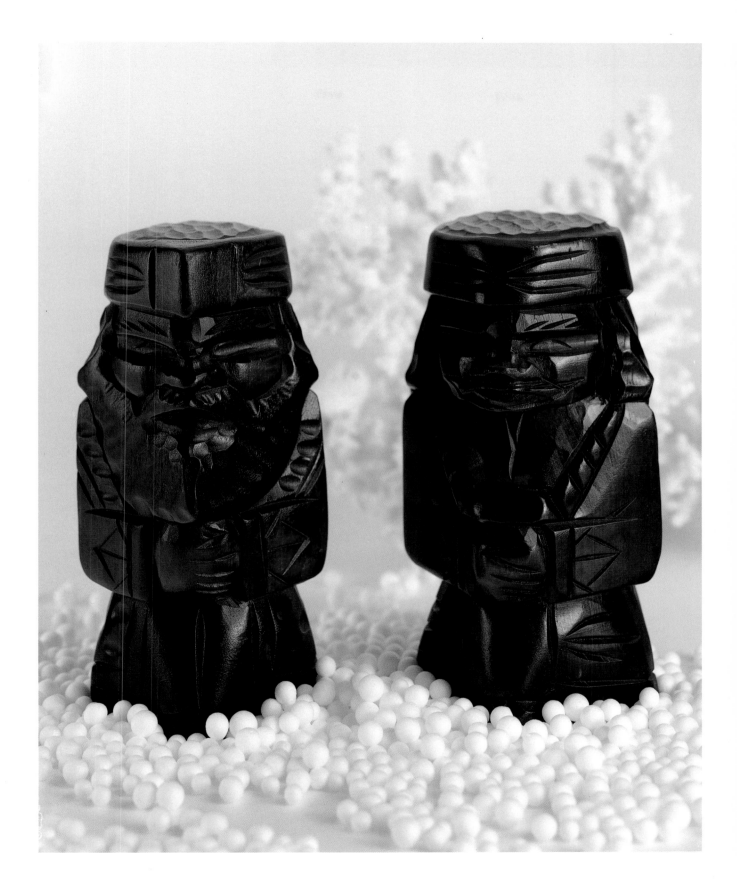

YAWATA HORSE

YAWATA UMA

WOOD

AOMORI PREFECTURE

The presence of the many horse toys made of wood, straw, and clay in the north of Japan is easily explained, for it was known as an excellent horse-breeding area. A mounted warrior was also more efficient than a foot soldier. In the Kamakura period (1192-1333) the Shogunate systematized horse-raising in this region into nine farms or *be*, as horses were needed for the many military forays of that time. As *hachi* means eight, the name Hachinohe or "eighth horse farm" was possibly derived from this division. Yawata Jingu in Hachinohe is a Shinto shrine dedicated to Hachiman, the god of war, so these colorful chargers are known both as Yawata horses and Hachiman hors-

es. On the 15th day of August, the shrine holds *yabusame* contests: shooting at a stationary target from a galloping horse. This is the ideal time for selling the red, black, and (more rarely) white miniatures to the visitors who come to see the spectacular sport. The first models were fashioned by a lacquerer who settled in the area. As the lacquerer of folk-craft items worked almost exclusively with red and black colors, he used his leftovers to decorate toys. The white horse is a later addition. The horses are square-cut, decorated with bands of patterned paper across the chest, suggesting the colorful trappings of samurai horses; they have stiffly implanted horsehair or palmetto fiber manes

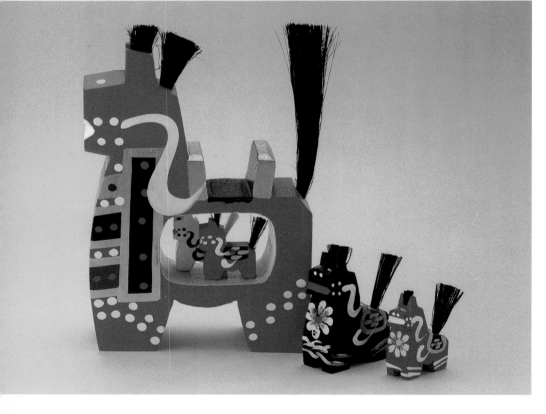

and tails, an unusually long neck, and are perhaps the most elegant wooden horses of the far north. Now sold as souvenirs, the horses were formerly hung from the neck of horses to protect them and their stables, and to ensure fertility. An amusing but true anecdote is told about the real horses of this area: European breeding stock had been imported in 1620 by the Date clan, just after the decree forbidding all things foreign. To save face the Date family drove the horses away into the adjoining territory of the Nambu clan who were ready to catch the "strays." Both clans raised handsome horses thereafter!

PIGEON WHISTLE

HATO-BUE

CLAY

AOMORI PREFECTURE

This colorful clay whistle in the form of a pigeon has long been one of the best-known toys of Aomori. In the Edo period, the feudal ruler of the area had a kiln built to fire the roof-tiles for his castle. When its role was fulfilled, the lord graciously turned the kiln over to his people, so that they might make household utensils for themselves, and toys to supplement their meager income. The whistles are mold-pressed and the two halves joined. After baking, they are painted a pure white in the likeness of a dove, or turned into a pigeon by the addition of bright pink, purple, and green colors on a white background. Although there are other animal whistles, the pigeon has always been the most popular. It is believed to cure children of hysteria, and licking the clay was said to be a sovereign protection against worms. As a bonus, the whistle's loud noise frightens away evil spirits! They return home like the pigeons and leave all in peace.

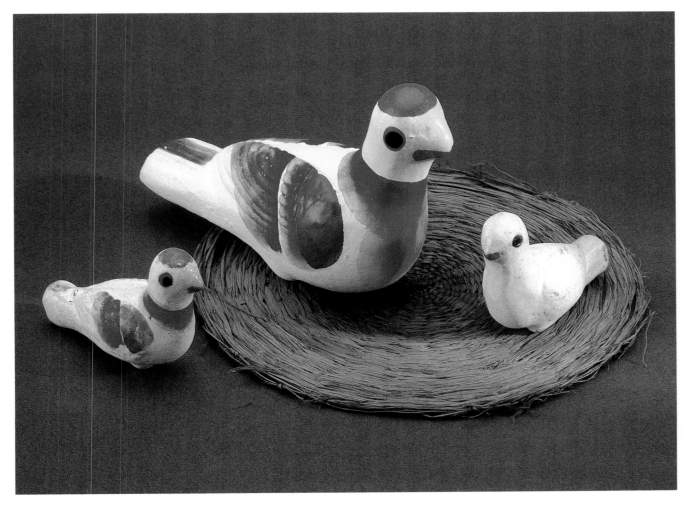

STRAW HORSE

WARA UMA

STRAW

IWATE PREFECTURE

A horse was a valuable possession, so when petitioning the gods for a favor, the rich often gave a real white horse to a shrine. Poor people solved the problem very simply—they gave *e-ma* or horse pictures—first woodblock prints stamped on paper, then drawings or paintings on wood, and by extension, miniatures of wooden or straw horses. The Iwate horse, also known as a "stealthy or secret horse" was formerly such a votive offering.

It is one of the best examples of a straw horse and is carefully and delicately made.

It wears a red, yellow, and black sash round the body, and a copper bell at the neck; the tail is raised vertically. The Tokyo Jindai Temple sells a very similar straw horse, but there the head is raised in a neighing posture and the tail is horizontal. The Jindai-ji miniature whose origin dates from the Tensho era (1573-1591) is based on a poem found in the "Man-yoshu," a 4,496 poem anthology of the Nara period, which tells the story of a nobleman riding to exile in Kyushu on an *akagoma* or red colt.

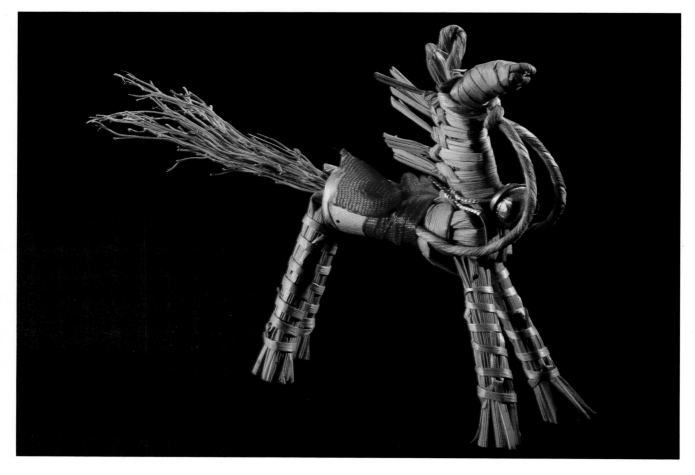

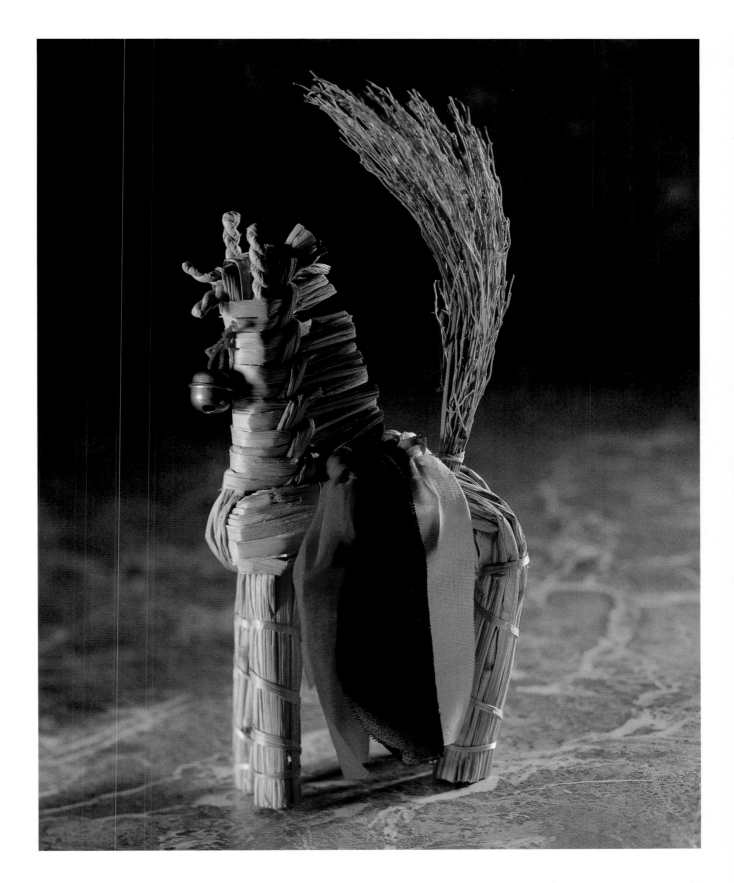

STRAW OX
WARA USHI

STRAW

IWATE PREFECTURE

At the end of the Heian era (794-1185) the north of Japan under the "strong man of Oshu," Fujiwara Hidehira (died 1189), was an almost autonomous region. At that time it was rich in cattle and horses, rice, and gold mines. One of Japan's remaining Heian-period temple buildings, the breathtakingly beautiful Golden Hall of Chuson-ji, is found here. In prosperous times, when the rice harvest was particularly bountiful, a cow or ox was covered with a length of richly woven brocade, topped by three bales of rice, and paraded through the streets. It was symbolic of the proud region's custom of sending rice to the emperor in Heiankyo (Kyoto). The straw oxen were once made at the beginning of the year as charms for a plentiful rice harvest and to bring fertility to the stables. They are now sold as souvenirs and amulets to tourists and travelers.

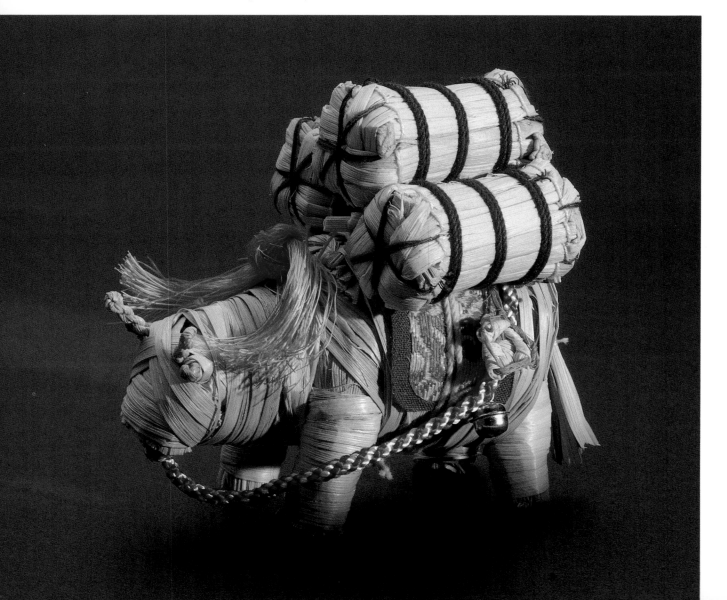

The legend relating to this toy is about 600 years old and tells the story of an old Buddhist priest, Kuya Shonin, who made friends with a lonely deer. It became his companion, and he cared for it in winter when it was cold and hungry. One day, wounded by the arrow of a hunter, it came to die at the feet of his good friend. Kuya Shonin buried it sadly, and it is said that he initiated a dance in memory of the deer. The dance is performed by seven couples dressed in beautifully decorated black costumes, wearing deer masks complete with horns and white hair. They have small drums strapped to the waist, which they beat with the drumsticks held in both hands. Although the legend is so old, the toys were first made in 1929. Strangely, the dance is called *shishi odori*, meaning "lion dance," even though the dancers wear deer (*shika*) masks.

CRYPTOMERIA GIRLS

SUGI BOKO

CRYPTOMERIA WOOD

AKITA PREFECTURE

Not as well-known as the famous one-piece *kokeshi* dolls of Akita Prefecture, these virginal young girls make charming souvenirs of the Snow Country. They are minimally shaped from a single piece of *sugi* or cryptomeria wood, which has a pronounced light and dark striped pattern, giving the appearance of charred wood. The dolls' clothes are painted to resemble the blue and white pre-dyed and home-spun *kasuri* pattern. They are wearing the straw *mino*, the typical snow-and-rain coat of the north, giving them a characteristic conical silhouette.

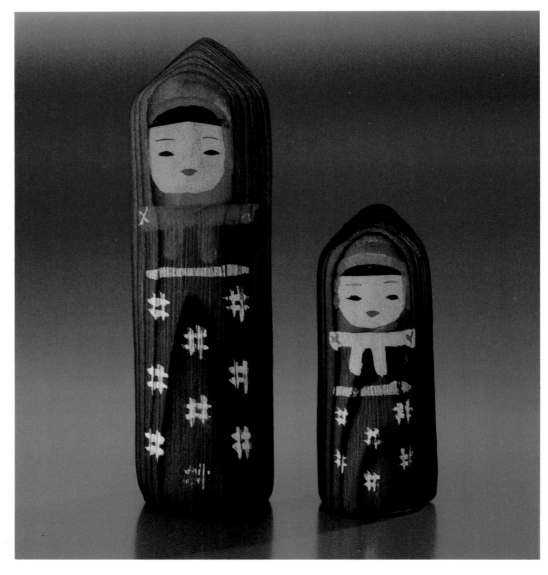

Itaya is the fine and strong grass-like straw used to tie and strengthen baskets at certain points. When wet, it can be twisted and bent easily into various shapes with a weaving and plaiting technique. Made from leftovers and left in their pleasing natural tone, the flat woven animals made at Kakunodate are easily included among the finest and purest examples of primitive folk art. In spite of their small size, they give a strong impression of arrested move-ment as seen in pre-historic cave art, and resemble the simple depictions of humans and animals found on the mysterious bronze *dotaku* bells of the Yayoi period (250 BC to AD 250). They are true folk art products that go back to the very roots of mankind, and it is regrettable that so few are seen in craft shops and folk art exhibitions. Attached to a fitting background and framed, they make surprisingly beautiful wall decorations.

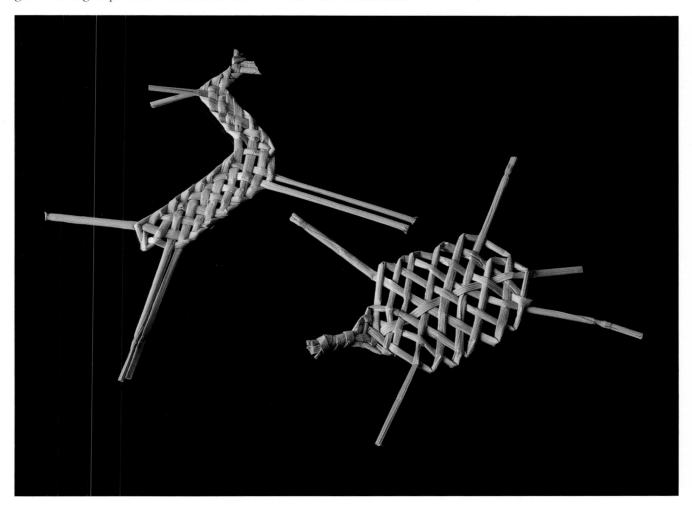

MATSUKAWA DARUMA

MATSUKAWA DARUMA

PAPIER-MACHE

MIYAGI PREFECTURE

With the end of the Edo period, the Tokugawa shogunate was abolished and the Meiji Emperor restored to power. Many samurai who had formerly received a yearly stipend for military service were left without an income. Some turned to toy-making to earn a living, and the Matsukawa *daruma* of Sendai was first produced by such an impoverished warrior. As there were so many *daruma* figures being made, this man conceived a very original toy to rival with the existing models, and to this day it has remained one of the most unusual. The Matsukawa *daruma* is elaborately and col-

orfully painted and even sprinkled with gold dust; he has encrusted glass eyes and real hair forming bushy eyebrows. This gives him a fierce countenance, good for keeping evil at bay. He stands on a boat loaded with rice bales, the prow of which is separately formed round the base of the figure. The sail shows the characters for *takara*, treasure. The whole composition indicates the *takarabune* or treasure boat which sails into the harbor on the third day of the new year, bringing many precious things or *takara-mono*, in this case the rice bales, symbolic of wealth.

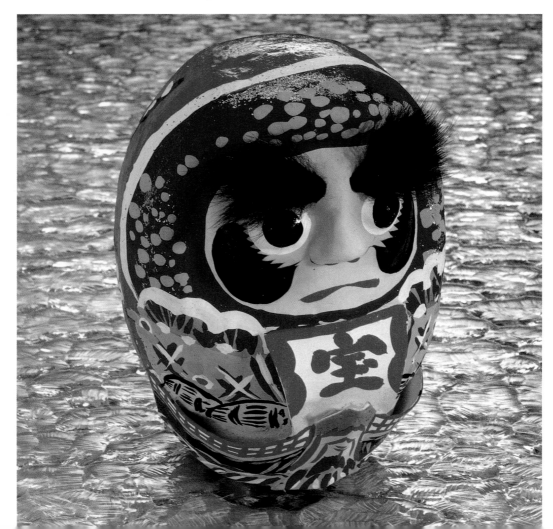

KOKESHI NINGYO

WOOD

YAMAGATA PREFECTURE

Possibly the most popular and best-loved folk dolls of Japan, *kokeshi* are made in the prefectures of Aomori, Akita, Iwate, Yamagata, Miyagi, and Fukushima, comprising the region known as Tohoku. The variations on the sphere-and-cylinder theme are truly amazing and form extensive subject-matter for collectors of *kokeshi*. The specific forms, facial features, and painted patterns are identifying factors, and, from them, connoisseurs can immediately tell from which prefecture the doll comes. The lathe-turning which gives the dolls their distinctive shapes is a purely mechanical process, done by apprentices, while the master does the painting.

The origin of *kokeshi* is thought by some scholars to lie with the two mulberry stick figures known as "Oshira-sama," used by shamanism to invoke the gods for protection and good silkworm harvests. They could also be derived from the unpainted *kina-kina* pacifiers (rattles) in *kokeshi* shape from Hanamaki in Iwate Prefecture. Another possibility lies in the name itself, which can be interpreted as meaning "poppy seed child" or "child erasing," for in years of famine, women were reduced to abortion or infanticide. *kokeshi* could thus have been memorial dolls, kept in the house to appease the spirits of the dead. In Japan, girls were less wanted than boys, and the *kokeshi* is always a girl. The most simple explanation is that they were toys made by farmers for their children, the craft later developing into cottage industries, producing souvenirs for the hot spring visitors, and in recent years, the ski resorts.

At present, defective or "unborn" dolls are still burned during the three-day *kokeshi* festival of Narugo in Miyagi Prefecture (7 to 9 September), with dedication of well-made dolls to the shrine deity on the first day and a cremation service for those that have defects on the second. The typical Narugo *kokeshi* has sloping shoulders and a large head that squeaks when turned.

Masters of *kokeshi* doll-making are proud of their craft, and the dolls often carry the name and age of their maker. The rare, one-of-a-kind, square-headed doll on the left is signed by the master Ishiyama Sanshiro; the delicately decorated black-patterned *kokeshi* was made by Kobayashi Seitaro, born in 1926. Both are from Yamagata Prefecture.

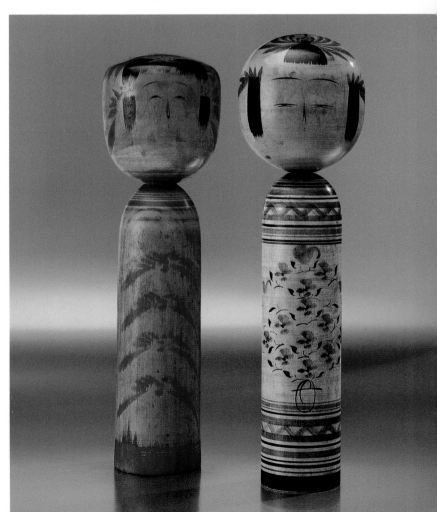

BABY IN A BASKET

IZUME KO

STRAW, TEXTILE

YAMAGATA PREFECTURE

Souvenirs from Tsuruoka, the children in baskets illustrate an old custom of wrapping up babies in a thick quilted cover or *futon*, and putting them in baskets in an upright position, while the parents worked in fields or woods. The mothers, busy at home, did the same, and the improvised playpen kept the little ones warm and out of harm. Small toys were tied to the edge of the basket for the children to play with. The first homemade miniatures were made with natural materials such as acorn cups, chestnut husks, and even fruit kernels, giving rise to variations on the theme and to many humorous interpretations. They are sold as souvenirs and charms for a happy family life and many descendants.

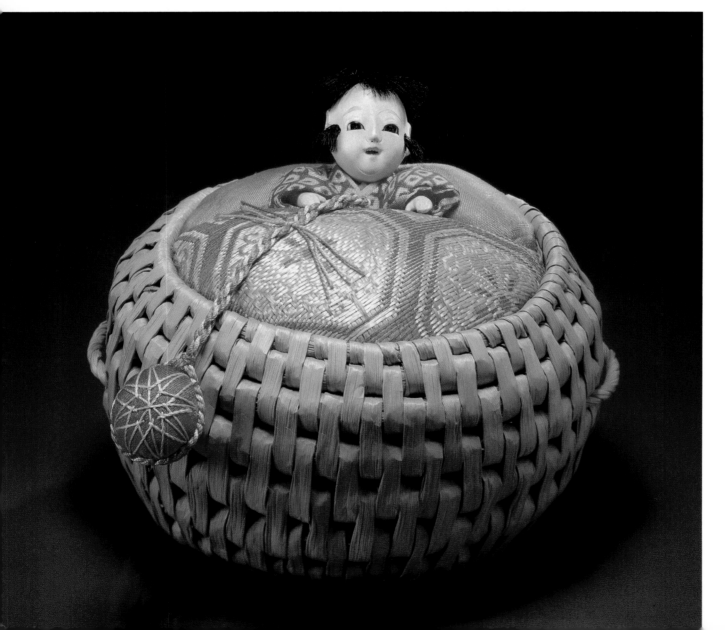

LION HEAD CLAPPERS

SHISHI-GASHIRA

WOOD

YAMAGATA PREFECTURE

These humorous lion head clappers are from Tsuruoka. They can perhaps be best compared to rattles, for the two parts of the jaws are tied together with string and make a clacking sound when the toys are shaken up and down. Quite well-finished, the heads are lacquered red for girls and black for boys. They are protective playthings, for noise frightens away evil spirits. The lion also has guardian duties and with closed mouth represents the yin or passive female principle; with open mouth, the yang or active male principle of the universe. As red is an active color, the passive girl plays with the red toy, while the active boy plays with the black passive one, so establishing a perfect balance of yin-yang elements while playing. In the East, even toys can contain philosophy!

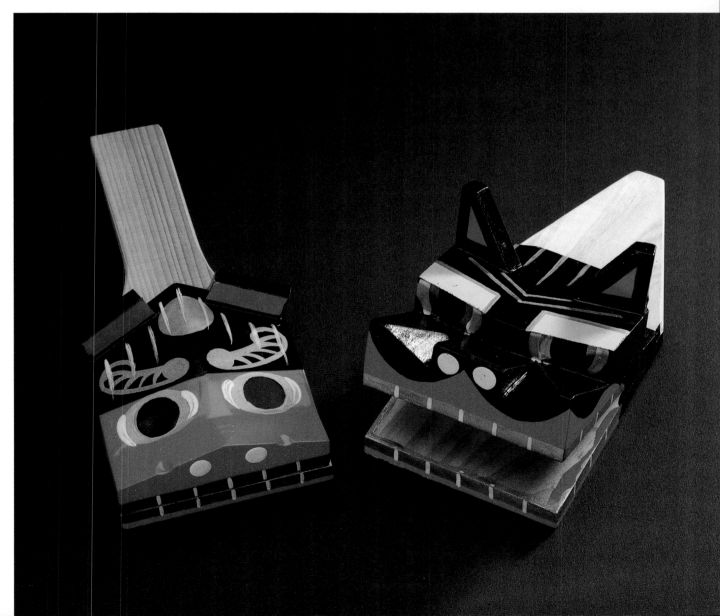

SASANO CARVING

SASANO-BORI

WOOD

YAMAGATA PREFECTURE

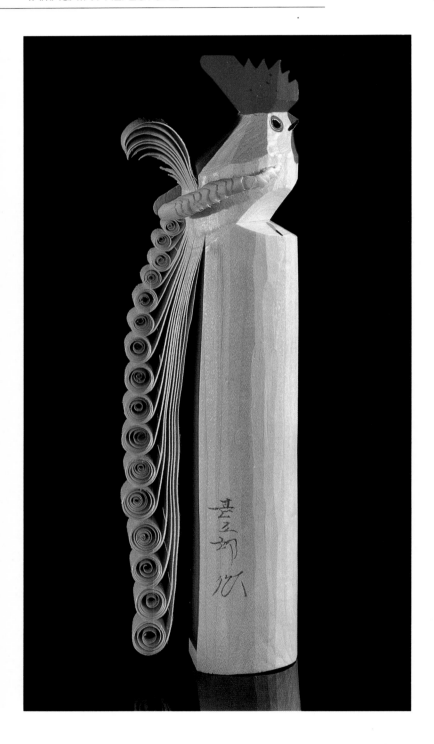

For their rituals, the Ainu aborigines of Hokkaido made wooden implements decorated with long, curling shavings named *inau.* It is undoubtedly this technique that inspired the villagers of Sasano to carve wooden flowers as offerings to their gods, and birds and animals observed in their everyday life. Like *kokeshi* dolls, the wooden toys were made to supplement the incomes of the farmers in winter. They were sold at temple festivals to be presented to the gods, or taken home as lucky charms and souvenirs. These original sculptures are a striking example of what can be done with a single cylindrical piece of wood, colors sparingly applied, and a heavy hatchet-like knife. The first figurines were mostly of hawks (*otaka-poppo*), but today all kinds of animals and exotic birds are made, including the popular *onagadori* or long-tailed rooster and a peacock with a spread tail. At Sasano, the village which gave its name to this type of carving, there is still an annual festival at the Temple of Sasano Kannon on January 17, where birds and animals of many different shapes and sizes can be acquired.

Aizu is an old name for Fukushima Prefecture, where, 350 years ago, the people of Aizu-Yanazu constructed a temple called Kyokyuzo-do. At that time wood and other construction materials were transported by cows and oxen. When the temple was completed, one of these animals refused to leave the grounds and faithfully kept watch by the temple gate. This unusual behavior drew large flocks of pilgrims and even high-placed persons. The monks began making small effigies of the cow with a swaying head as amulets for believers; known as calves, they were said to be children of the original cow. Their popularity was assured at the time of a smallpox epidemic, when those who possessed amulets were not touched by the illness. This is, however, the edifying version of the story, for it is also known that when people visit Fukushima, they write back to their friends that "this is indeed the land of Ohara Shosuke (a well-known drinker and hedonist) for even the cows have red noses from drinking too much!"

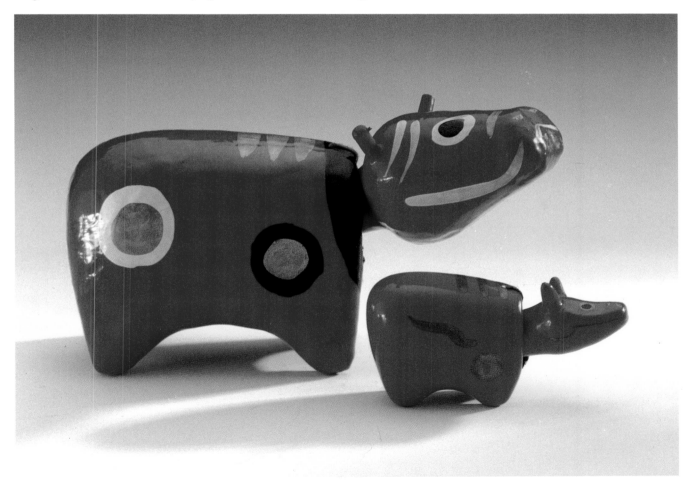

MIHARU HORSE

MIHARU KOMA

WOOD

FUKUSHIMA PREFECTURE

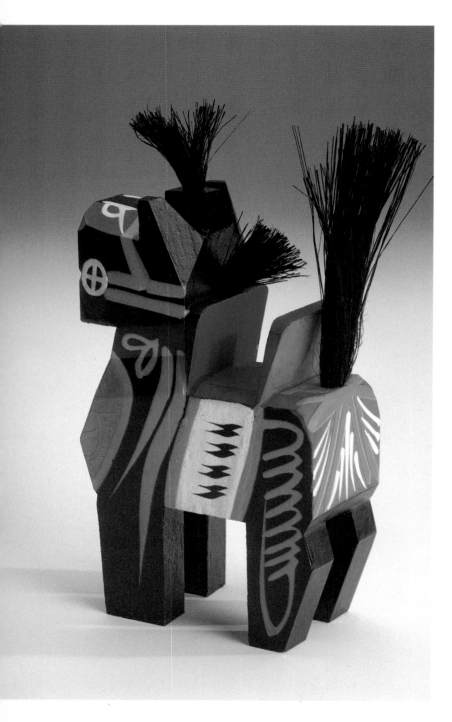

This square and sturdy steed was born of a legend worth recounting. In Heian times (794-1185), the general Sakanoueno Tamuramaru was sent by the emperor to subdue the turbulent northern provinces. Before leaving, the general went to pray at Kiyomizu Temple in Kyoto, and as amulets for victory, was given a hundred small wooden horses carved from the leftover pieces of a great image of Buddha. At Miharu, the battle was going against him, when a herd of a hundred horses suddenly appeared and overran the enemy forces. After the battle, the general found that his horse charms had disappeared, but the next day a villager from Takashiba found one small wooden horse covered with sweat and blood... for one horse had been wounded. After these remarkable events, the people of Miharu and Takashiba made miniature copies of the wooden horse as amulets for the health and safety of their children. The product of this legend is a square-cut, powerful figure with brightly colored trappings of red, yellow, blue, and white on a black ground. It is another witness that true folk craft is an enduring tradition that survives the passage of time with ease.

One of the most interesting types of papier-mâché toys produced in the Edo period is the Miharu doll of Takashiba. In an effort to develop the region's economy, artists from Edo introduced exotic models of personages that the people of the countryside had never seen: kabuki actors, *sumo* wrestlers, courtesans, dancers and musicians, as well as the usual historical, mythical, and luck-bringing toys. What is remarkable about these figures, is that more than in any other type of rustic Japanese doll representing the human form, there is an effort to capture expression and movement. The result is sometimes rather comical, but in the best cases it gives a fresh and naive charm to the figurines. They are always detailed, with accessories such as headdresses, fans, swords, and bells well rendered. The dolls are formed by pasting layers of paper over a mold; when dry, this outer shell is cut open, removed and painted. This process makes it possible to have many separate parts and join them into complicated figures with exaggerated poses, resembling the sophisticated Takeda dolls of Osaka. The older dolls, their bright colors softened by the muted patina of age, are aesthetically more pleasing than the new.

JUMPING-UP PRINCESS

OKI-HIME

CLAY, PAPIER-MACHE

FUKUSHIMA PREFECTURE

In Japan, the *hatsu-ichi* or first fair of the year, is an important event. It is there that are acquired the good luck charms ensuring the health, happiness, and prosperity of all the people stepping into an unwritten page of the future. The little red tumbler toys sold in the old castle town of Aizu-Wakamatsu are famous all over Japan. About three centimeters high, the black-haired princesses are made of papier-mâché on a rounded clay base. There are also larger and slightly more sophisticated Okihime, with crossed white lines decorating their red kimono. Like *daruma*, they always return to the upright position... an encouragement to do likewise when struck by misfortune. It is customary to buy an Okihime for every member of the family plus one. This one will serve as a decoy for any evil threatening the household, and should be placed on the *kamidana* or sacred shelf, where gods and protective spirits are honored.

Kanto District

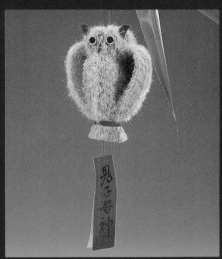

Prefectures of

**CHIBA KANAGAWA TOKYO
GUNMA SAITAMA
IBARAKI TOCHIGI**

STRAW DOLLS
WARA NINGYO

STRAW, TEXTILE, WIRE

TOCHIGI PREFECTURE

Tochigi was always known for its many strong and functional straw gardening and cleaning tools such as brooms, brushes, and baskets. Undoubtedly craftsmen made straw toys as a sideline. In the past, even life-size straw figures were made to test the cutting power of a newly-forged sword. The proud archer is skillfully made from *kibigara* or millet stalks. The inspiration for military figures was furnished by the festival of the Nikko Toshogu Shrine held on May 17 and 18. The festival is in honor of Tokugawa Ieyasu, unifier of Japan and the first shogun of the Edo period. One of its highlights is a parade featuring the traditional costumes of his time. The toy represents an archer at a *yabusame* tournament, shooting at a stationary target from a galloping horse. The crane and long-tailed tortoise are the most popular symbols of happiness and longevity, as they are said to live thousands of years. The tortoise has lived so long that aquatic plants have grown on its shell and formed a tail!

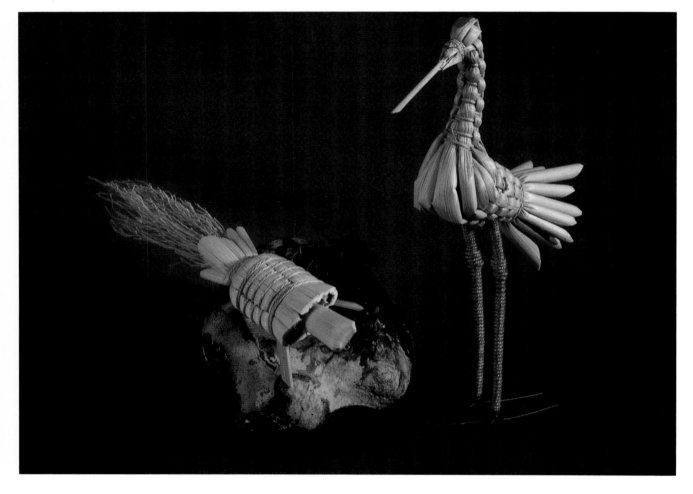

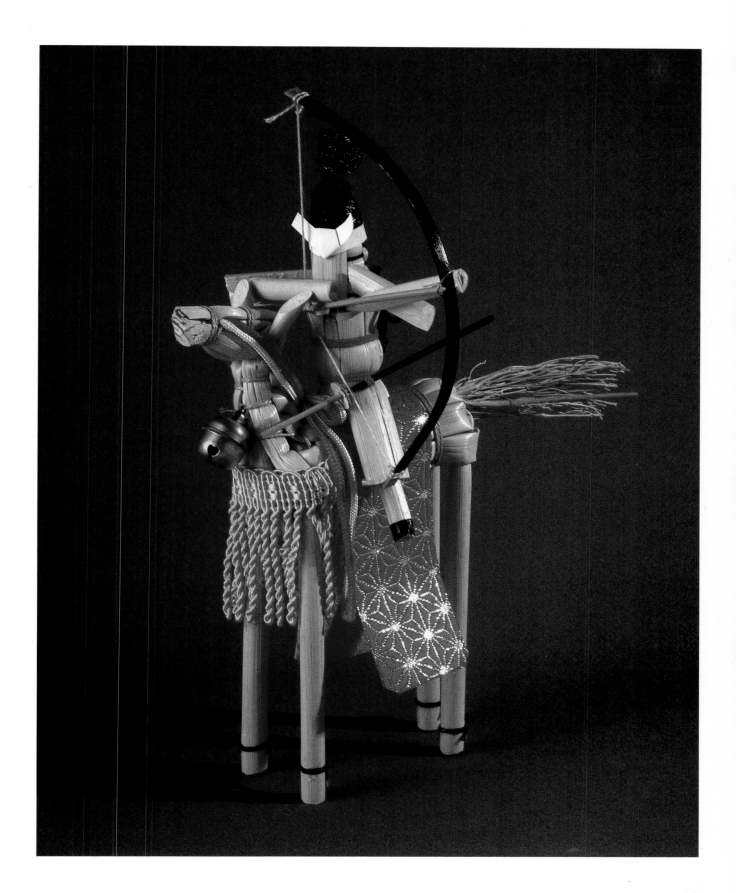

SHIMOTSUKE PAPER DOLLS

SHIMOTSUKE HITOGATA

PAPER

TOCHIGI PREFECTURE

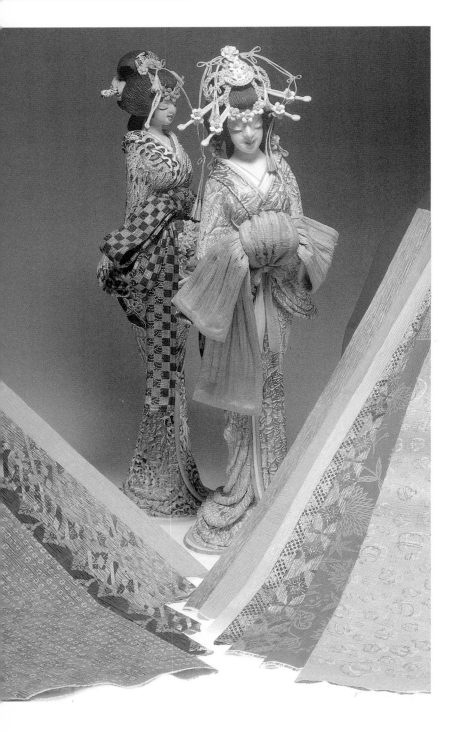

Shimotsuke is the old name for present-day Tochigi Prefecture, and one of the specialties of the region was the making of paper dolls. Today the craft is carried on by one man and his wife. Shigeo and Shizuko Suwa still make these dolls using time-tried methods, for the handmade paper must be rolled, unrolled and squeezed many times around a cylinder to give it the suppleness and pliability of textile. This technique is called Shimotsuke *shibori*. The Suwas have a school, and their art has been designated as an Intangible Cultural Asset. It gives hope for the future and encourages those who learn to work in traditional ways, that a group of small Shimotsuke figurines is shown at the Tochigi Folk Toy Museum, and that a nearly life-size Heian lady doll is permanently exhibited at the N.H.K. Television Center in Tokyo. The couple has been honored by exhibits of their dolls in many foreign countries. Their work is a perfect example of an old and honorable art adapted to changing times without concessions to the ancient standards of excellence.

GOURD DARUMA

HYOTAN DARUMA

NATURAL GOURD

TOCHIGI PREFECTURE

The Japanese have an inherited genius for making the most of the natural materials available in their country. The gourd is alternatively a spoon, a *netsuke*, a saké flask, a powder container, a charcoal holder, a food bowl...all depending on its natural form and the way it is cut. In this medium, Tochigi is famous for *sumitori* or charcoal containers, demon masks, and a painted-on *daruma* who certainly makes an original addition to any *daruma* collection! As this gourd *daruma* is firmly anchored to his base, he cannot roll over like most other *daruma* toys, so he is considered as a potent charm against accidents by falling.

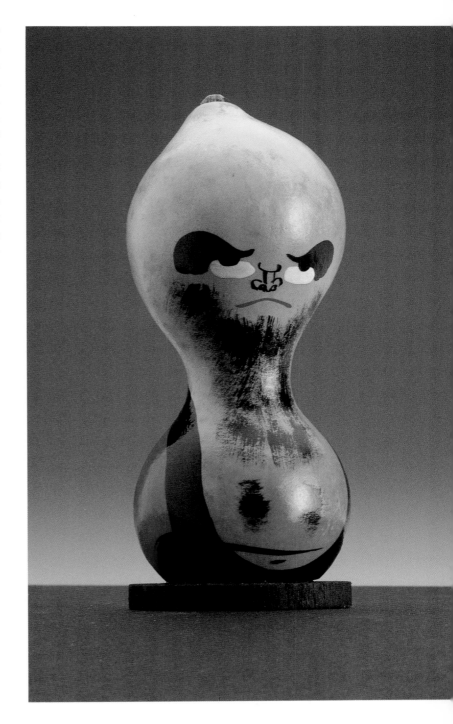

41

MAYUMI HORSE

MAYUMI UMA

SUMAC WOOD

IBARAKI PREFECTURE

The Mayumi horse owes its name to the village of Mayumi, famed for horse-breeding and the special wood, sumac, from which the earliest amulets were made. The overall impression is that of an authentic and vigorous folk tradition. The third oldest toy in Japan, it was always made at the Kokuzo Temple of Muramatsuyama, a Buddhist temple established in 807. In the 1960's, only one priest was making the horses, but cutting them from *sugi* (cryptomeria) instead of the scarcer sumac used for the original type. However, the appearance is absolutely true to the older model; the toy is cut from a flat board and highly stylized. The colors are strong but sober; a saddle is simulated on the back by two small sloping pieces of inserted wood. The miniature horses were formerly sold as charms for prosperity and safety on the 13th day of each month, when a market was held at the temple. Pilgrims who went to the temple on January 15, when the great *Shuseikai* prayer meeting was held, also returned home with a Mayumi horse.

Similar amulets, though poorer in color, are seen at the Tamukeyama Hachiman Shrine, a Shinto shrine in Nara Prefecture. First made in the eighth century, they were substitutions for real horses, offered to the rain god. The Tamukeyama horse, the Mayumi horse, and Empress Komyo's dog charms are known as the three oldest toy-amulets in Japan.

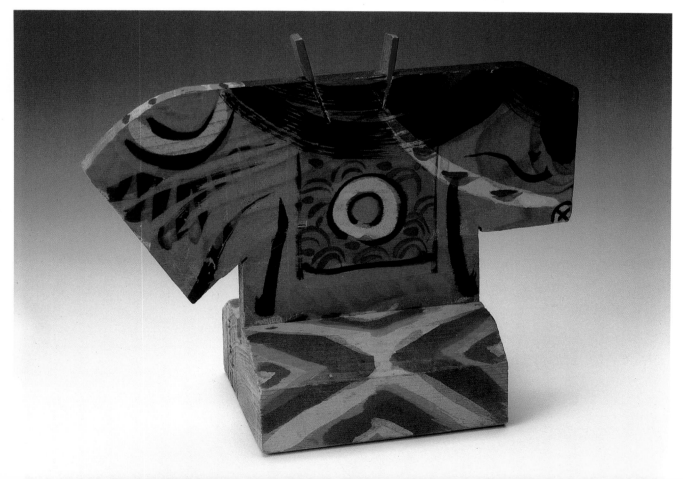

This figure of *okiagari koboshi*, the rising-up little monk, is the most popular *daruma* of Japan. He is sold as an *engi* or luck bringer at the Shorin-zan, a Zen Buddhist temple of Takasaki, on January 6 and 7. On January 9, another *daruma* street market is held at Gunma's Maebashi. Rain or shine, literally thousands of papier-mâché toys, ranging from mini to maxi, are sold on these days. Gunma produces 1.3 million figures annually, or 70% of the total quantity made. The toys are made (or should be) by pasting paper round a wooden or stone model, cutting open and reassembling when dry. *Daruma* is then weighted with clay and painted bright red with gold and black decoration. The eyes are left blank, for one eye (usually the left) must be filled in when a wish is made, the other when the wish is granted. A charming legend tells that a Buddhist monk who was perhaps Bodhidharma (Daruma) in disguise, made a wooden *daruma* image for a farmer who had treated him kindly. Not wanting to sell the original carving, the farmer molded papier-mâché round the figure and made copies for sale. And so the first *daruma* toy was born and the friendly farmer made his fortune!

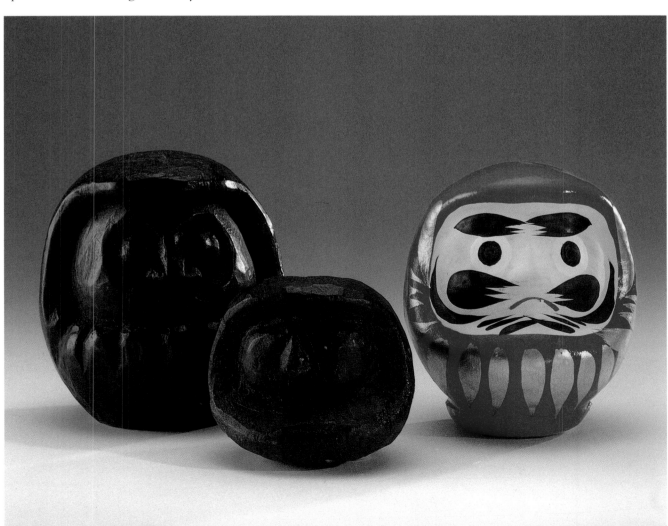

LION HEAD
SHISHI-GASHIRA

SAWDUST, RICE PASTE

SAITAMA PREFECTURE

The snapping *shishi* is an uncontested Chinese import, its open-closed jaws have much to do with the yin-yang elements of the universe. In China a pair of guardian lions, one with an open and the other with a closed mouth, was placed before temples and palaces, a practice taken over by Japan with the introduction of Buddhism. The exuberant new year festivals featuring lions and dragons were also enthusiastically incorporated into Japanese life, and the *shishimai* or lion dance is perhaps now seen more in Japan than in China. The lion head toys with clapping jaws activated by a bamboo spring have been popular since the early Edo period, and are found throughout Japan. They are lacquered red for girls and black for boys; there are also plain sculptured wood ones. Red *shishi* heads, however, are more current, as the red color has the supplementary virtue of keeping away evil spirits. The heads from Saitama Prefecture were first made by settlers, the (Chinese?) builders of the Toshogu Shrine, the mausoleum of Tokugawa Ieyasu, which in its bright colors, lavish ornamentation, and general inspiration, follows Chinese models. The toy is a popular keepsake of Saitama.

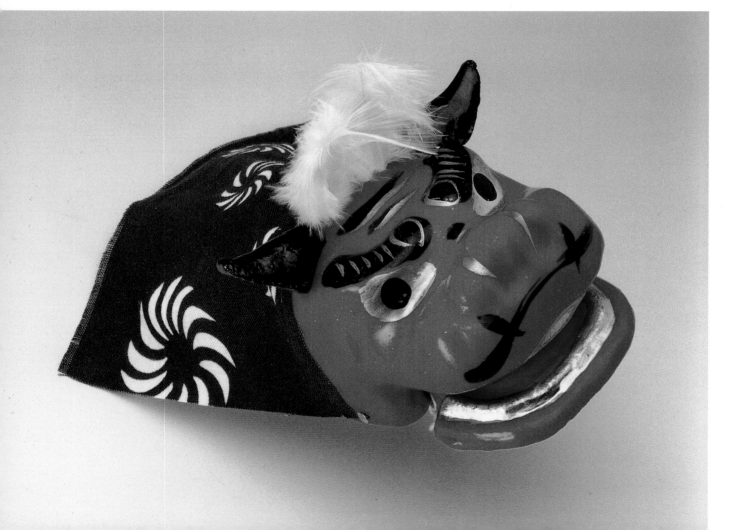

Japan is a country with a rich store of legends, peopled by ghosts and goblins. Wicked badgers and foxes roam the countryside to waylay the traveler, and even inanimate objects like lanterns and umbrellas can serve as a disguise for demons. An infallible sign of a supernatural being is the absence of feet, for a ghost tapers away and floats. The papier-mâché dolls from Koshigaya form an amusing version of umbrella ghosts, who, being hung up on a string, bob about in the breeze, shaking a head at the end of a long neck. These colorful and harmless goblins, who are also known as "one-legged dolls" have existed since the Edo period, and are still amusing children from age nine to ninety. The ghosts are sold as souvenirs...and just for fun.

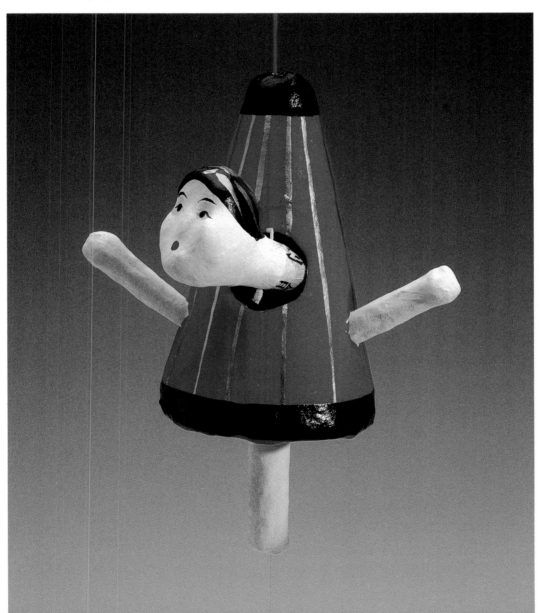

SHOGUN MARKERS

SHOGUN-HYO

WOOD

SAITAMA PREFECTURE

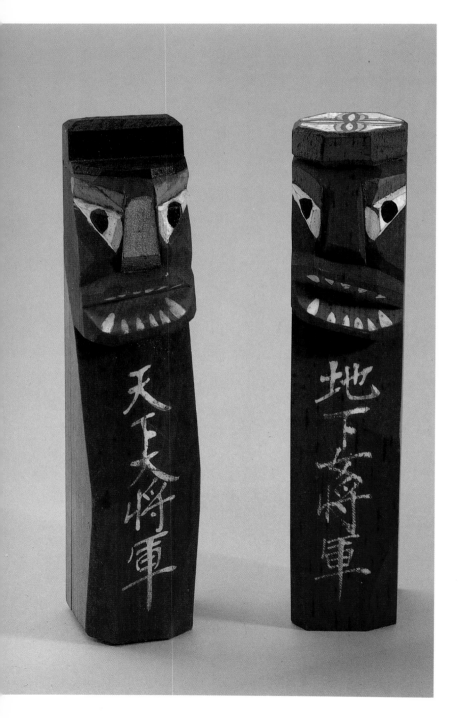

These peculiar totem-like figures are of Korean origin. After Toyotomi Hideyoshi's two unsuccessful invasions of Korea in 1592 and 1597, many craftsmen were brought back to Japan to practice their specialties, such as weaving, sculpture, and porcelain making. They brought their own protective charms from their homeland, where similar larger "protectors" are seen along the paths leading to villages, guarding their territory. Others hang from trees averting danger from the sky. They have threatening faces to keep away evil spirits. On the body of the male figure is written *Tenka-Dai-Shogun* or Great-Shogun-under-Heaven, on the body of the female figure *Chika-Onna-Shogun* or Woman-Shogun-under-the-Earth. As the shogun was the most powerful person in Japan, the charms are said to be equally potent against harm. The angular figures are painted brown in front with white eyes, teeth, and writing. The male wears a plain black cap, the female a blue and white flat hat decorated with a four-leaf flower. They are essentially protective gods against all kinds of accidents and natural disasters coming from the sky and under the earth... in the case of Japan and Korea, earthquakes and typhoons, and on another scale, the birds and insects that attack crops. Besides all this they also bring luck for the future.

CLAY DOLL HEADS
TSUCHI KUBI NINGYO

CLAY, STRAW

CHIBA PREFECTURE

These clay masks are made in Kashiwa, where a Tokyo doll-maker started the tradition about fifty years ago. Hand modeled and brightly painted, the amusing caricatures are typical examples of naive folk art. There are various versions of these little heads, the three most popular being the twelve animals of the oriental zodiac or *jun-ishi*; the seven Japanese gods of good fortune or *shichifukujin*; and some fanciful comic masks. Inserted in a straw bundle by bamboo sticks, they can be hung up as an original and colorful wall decoration.

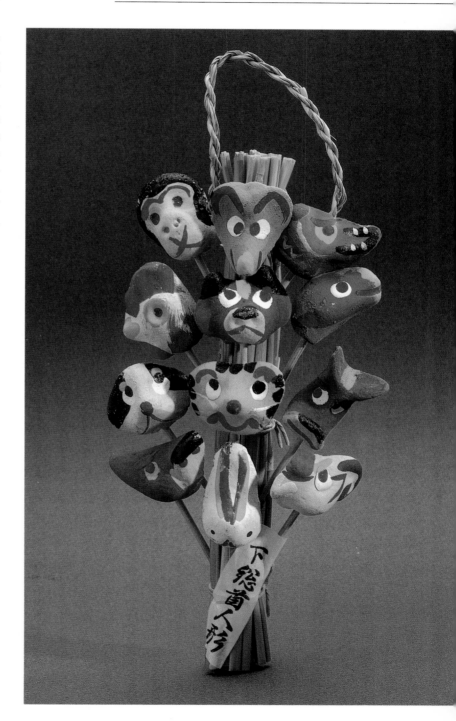

SOMERSAULTING TOYS

TONDARI-HANETARI

PAPIER-MACHE, BAMBOO, THREAD

TOKYO

This jumping toy, a novelty of the Edo period and still rare today, was originally made at Asakusa, near the Kannon Temple, where many pilgrims flocked to pay homage to the Goddess of Mercy. The little figure is fixed to a curved bamboo base, hiding a simple thread-and-stick spring. The toy wears a separate hat and a demon or animal mask, nearly hiding it entirely. When the bamboo spring is pulled back and released, the figure makes a complete somersault and the covering falls off, to reveal another face underneath. Sukeroku, the little shop in Asakusa's Nakamise street selling miniature copies of Edo-period toys, has used this amusing and delightful automaton as decoration for its wrapping paper since 1773.

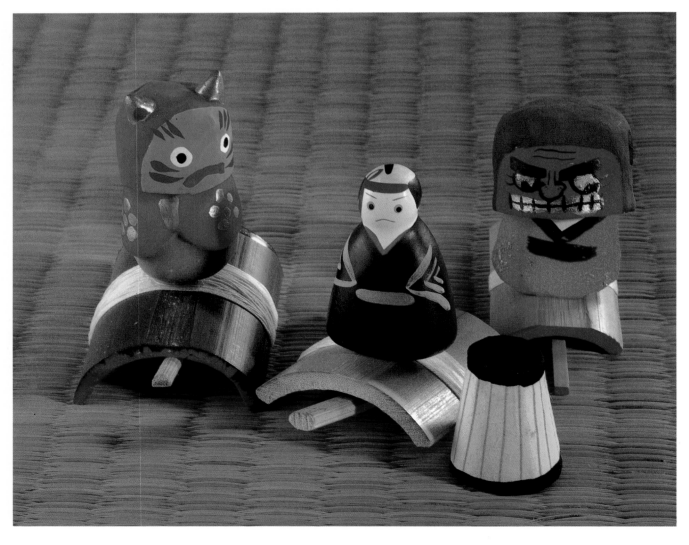

GODDESS OF MERCY

KANNON

PAPER, CLAY

TOKYO

Another Edo-period novelty found illustrated in the woodblock-printed book of 1773, "Edo Nishiki," is this "secret" Kannon, hidden in a decorated paper cylinder. It is a rare toy, for religious figures are seldom used as playthings. When the stick is pushed up, a radiant Kannon appears, surrounded by the golden rays of a pleated paper fan. Senso-ji, also known as the

Asakusa Kannon Temple, was built in 645, in honor of a six-centimeter-high golden Kannon, or Goddess of Mercy, which was found in the Sumida river by two fishermen, the Hinokuma brothers, in 628. It is a "secret" statue, displayed only every 60 years, so this was undoubtedly a popular trick-plus-amulet toy for the many pious pilgrims visiting Senso-ji.

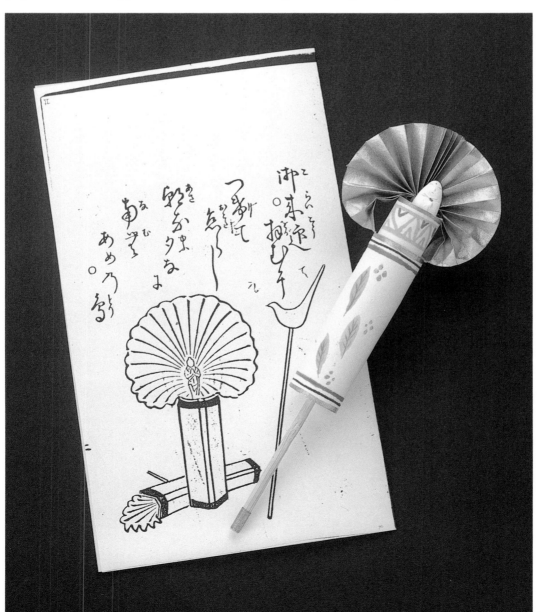

CAT AND MOUSE

NEKO TO NEZUMI

WOOD, CLAY, PAPER

TOKYO

An ingenious plaything of the Edo period, with a probable Korean origin, this trick toy shows a cat lying on top of a wooden box. A mouse is attached underneath the lid by a paper roll on a cylinder. When the lid is pulled back and open, the paper is tightened and a mouse appears in front of the cat. When the lid is pushed shut, the mouse disappears... so it can never be caught!

Another version has a father playing the "cat and mouse" game with a baby hidden in the box. Yet other tiny toys—they range from three to five centimeters—are a two-mouse merry-go-round, a mobile toy depicting a strong man sawing wood, and a *maneki neko,* the beckoning cat that invites customers and prosperity. These toys are for careful adults only!

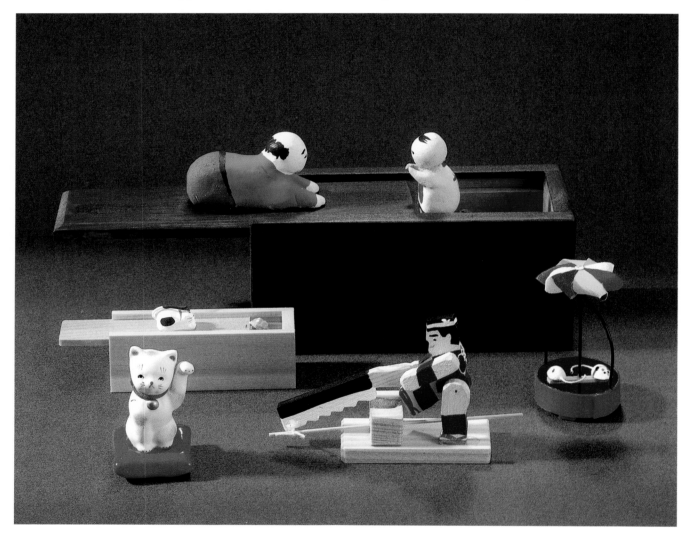

This intriguing toy based on a tightrope walker turns up on many Edo-period documents and objects, such as illustrated books, woodblock prints, lacquer boxes, and *kozuka* (knife handles). It can also be a decorative design on textiles, or form heraldic *mon* or crests. Various versions of the toy (acrobat, samurai, scarecrow, *ninja*) are still sold throughout Japan and it is also found in Korea and India. Judging by all these decorative aspects, it must have enjoyed considerable popularity in the Edo period, so it is surprising that its origin is shrouded in mystery.

The name Mamezo came from the term by which street entertainers were generally known. Their name, in turn, derived from that of a famous street acrobat and tightrope walker called Mamezo (freely translated this means "made of beans"). Mamezo knew his greatest fame in the Genroku era (1688-1704).

In Japanese, *mame* can mean something as small as a bean, thus a miniature representation, but it might also indicate that the very first toys were weighted with beans or made of beans, as present-day ones are sometimes

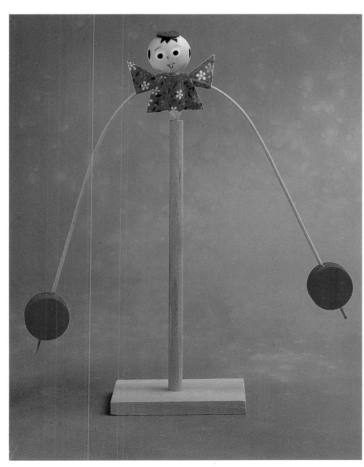

assembled with nuts. So was Mamezo named after the toy, or the toy after Mamezo? There are also Yajirobei and Kitahachi, two (legendary?) heroes of the Edo era (1603-1867). Stories of their farcical Don Quixote-type antics along the Tokaido Road kept readers laughing, and perhaps Yajirobei also lent his name to the toy.

Two versions of the Mamezo as a decorative motif are illustrated. It is used as a beautifully stylized design on the padded coat of the *komori* or nursemaid in the woodblock-printed vertical scroll (*kakemono-e*) by Kunisada. The signature "Kochoro Kunisada" was one he used during 1829-1830, and the notation "*oju*" indicates that the print was made by spe-

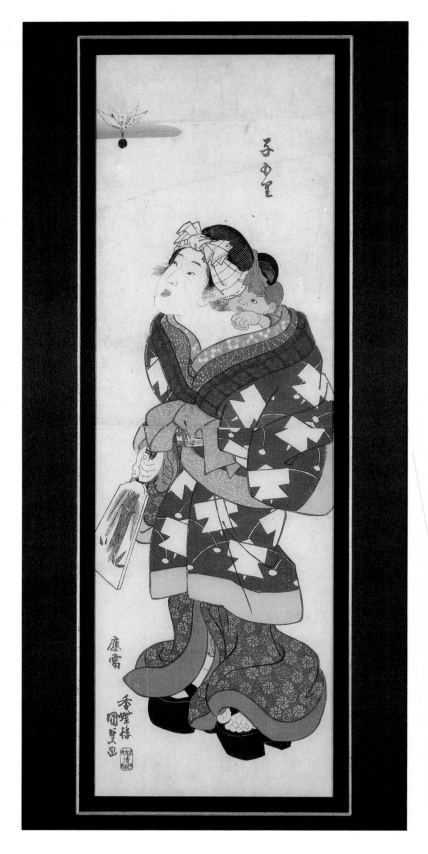

cial request. The little nursemaid carrying an attentive baby on her back is playing with a *hagoita*, a toy of Chinese origin, symbolic of the new year season.

The *kozuka* or knife-handle is made of heavily gilt metal and shows an itinerant toy-seller holding a Mamezo figure aloft with his right hand, while supporting the box slung from his neck with his left. More toys are visible in his box. The engraving is masterfully done, showing the different textures of the straw hat and sandals, the wood-grain of the box, and the various patterns of the clothes. The subject is playful and somewhat rare for a weapon, indicating show rather than real use. This *kozuka* was undoubtedly a fashionable fad of the Edo era. It is signed Naomasa, a well-known 18th-century maker of sword fitting.

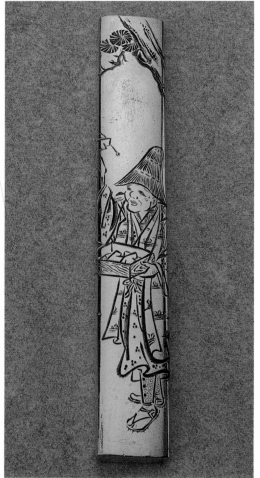

This amulet is sold during the annual fair at Kameido Tenjin Shrine in Tokyo on January 25. The ritual of returning the previous year's bird to be burned and buying a new one is also observed here, as at most other Tenjin shrines... although some do escape the flames and alight at flea markets. It is a simple cylindrical little bird, with only three flat, black-and-green tail feathers, a gold back, a black head, white eyes, and a red breast and beak. The first sale at Kameido was held in 1820, when the lucky buyer of a specially marked bird could win a gold bullfinch. It seems that the prepared 20,000 miniatures were immediately sold, so the priests put up an ambiguous notice reading "All our *uso* sold out." Lies? Bullfinches? as the word *uso* has both meanings, this

famous signboard contributed to the festive atmosphere and set the populace laughing. To the further joy of the people, a well-known poet of the day, Ota, riding past on his horse, added the somewhat malicious lines·

> So is the true way of the gods revealed to us all!

At present, holders of specially marked birds receive copies of famous poems or painted scrolls. The Osaka Tenjin Shrine gives three prizes, a gold, a silver, and a bronze plaque embossed with the image of a bullfinch.

PAMPAS GRASS HORNED OWL

SUSUKI MIMIZUKU

SUSUKI (Eulalia japonica)

TOKYO PREFECTURE

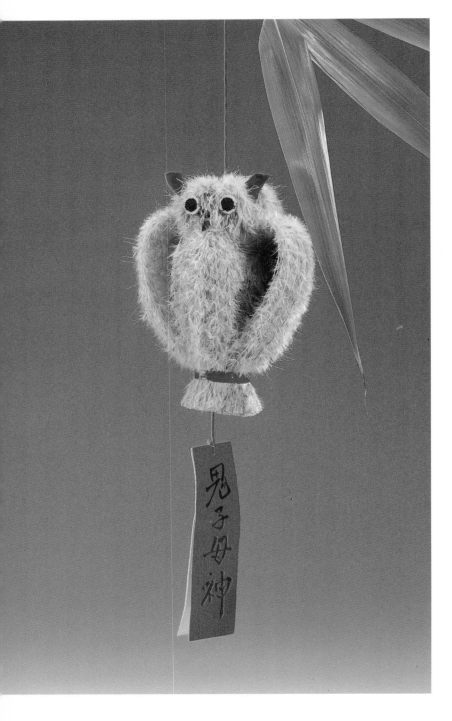

This unique toy-amulet is a protector against illness. It has a history dating back at least 250 years, for its image is found on documents of the Edo period. It can be bought at the Zoshigaya Temple, dedicated to Kishibojin, from 12 to 18 October. Sold attached to a twig of green bamboo, it is made of seed heads of pampas grass, curved and tied in a very inventive manner. It has red ears, black and white eyes, and a dangling red streamer reading Kishibojin on one side and Zoshigaya on the other. Kishibojin was first an ogress who ate children, but converted by Buddha, she became a Buddhist saint and a protective deity of children. The story of the amulet's origin is that a poor girl came to pray at the temple for her sick mother for whom she had no medicine. Kishibojin appeared to her in a dream and told her to make owl amulets for the temple visitors. As the girl had no money to buy materials, she picked wild pampas grass and made attractive, downy owls which soon became a popular feature of Zoshigaya Temple. In this way she earned money to buy food and medicine for her mother. In Japan, the owl is generally considered a malefic and ungrateful bird, capable of devouring its mother. Here, on the contrary, it is symbolic of a girl's devotion. A second version of the original owl, also dating from the Edo period, shows it sheltering two owlets under its wings, so the child-eating Kishibojin and the mother-eating owl have become symbols of evil turned to good. Zoshigaya's grass bird also doubles as a barometer... it is fat and fluffy in fine weather, but becomes thin and limp at the approach of rain.

YAKKO KITE

YAKKO-DAKO

PAPER AND BAMBOO

TOKYO

The writing on this delicately made kite says that it is a protector against fire. Fire was a feared and ever-present danger in the large towns of the Edo period, when an accidentally overturned oil lamp or charcoal brazier could wreak havoc among the flimsy wood-and-paper constructions, laying waste whole districts in a few hours. A kite symbolically cuts through the wind, and so reduces its power to fan flames. This kite represents a *yakko*, one of the lowliest servants of a nobleman, who forced the populace to kneel and rather brutally cleared the way for his master during his travels. Kite flying is one of the traditional games for boys at the new year, so this mini-kite is sold on the first and second day of January at the Oji Inari

Shrine... perhaps to clear the way to a happy and fire-free year. The *yakko* is soberly woodblock printed in tones of red and black, with a touch of blue on the head, and pale yellow for the sword. The armature is beautifully formed with thin bamboo strips. It is a charming kite for collectors.

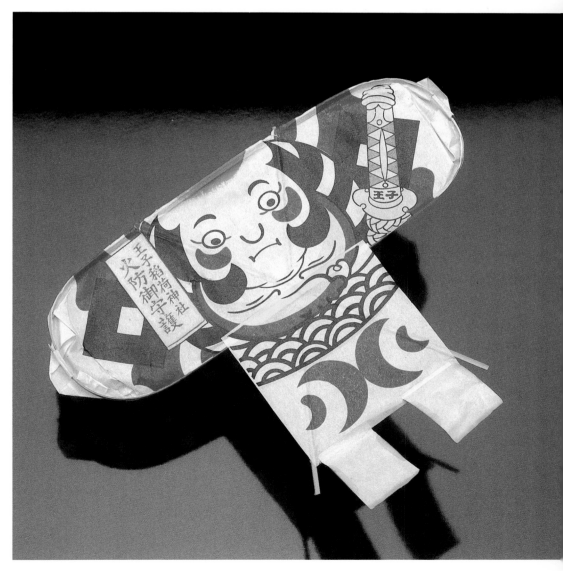

"WAIT A MINUTE" FOX

SHIBARAKU KITSUNE

PAPER, BAMBOO

TOKYO

Another ingenious toy sold all year round at the Oji Inari Shrine represents a white fox, messenger of Inari the rice god, grantor of riches and abundant harvests. The fox is dressed in the kabuki costume of the actor Ishikawa Danjuro the ninth (died 1903). The famous *mimasu* (three rice measures) crest of the Danjuro line represented on his sleeve also alludes to the rice god. Danjuro came to the Oji Shrine regularly to pray for

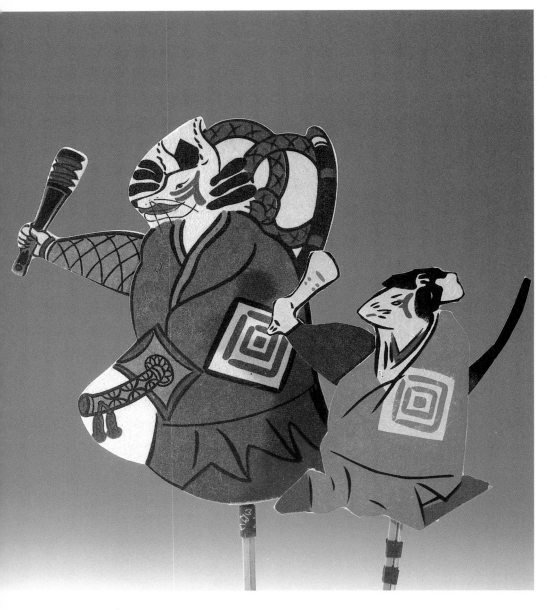

success in his artistic career, of which one of the highlights was his heroic role in "Shibaraku," a word translated as "wait a minute" or "just a moment." "Shibaraku" is the angry cry of Kagemasa Gongoro when he comes upon a gang of brutes terrorizing helpless people. He fights the evildoers, cuts off a few heads, and becomes the people's hero. This play of derring-do has always been one of the most popular in the kabuki repertory, and is one of the "18 Famous Plays" reserved exclusively for the Danjuro family. This is a mobile toy, the arm moving in the grandiose "Shibaraku" gesture when a bamboo stick is moved up and down. The fox on the left is contemporary, woodblock printed in subdued tones of black and brown, with touches of red and greenish-blue. On the right is a smaller and older version, showing the toy's evolution.

56

PAPIER-MACHE DOG

INU HARIKO

PAPIER-MACHE

TOKYO

In Eastern lore the dog has always been known as a watchful guardian of people and property. It was credited with the power of discerning demons in human disguise. A small child was never taken out after dark without having the protective ideograph for dog written on its forehead with red ink. Because dogs give birth easily, dog charms are sold as amulets for a safe pregnancy and childbirth. The ancestor of the present-day toy was the Azuma dog from Nihombashi, a realistic representation found in the woodblock-printed book "Edo Nishiki" of 1773. This toy went out of production in the 1920's; then, as now, it was customary to take babies to be blessed at the family shrine, 31 days after birth for a boy, and 33 days after birth for a girl. The brightly paint-

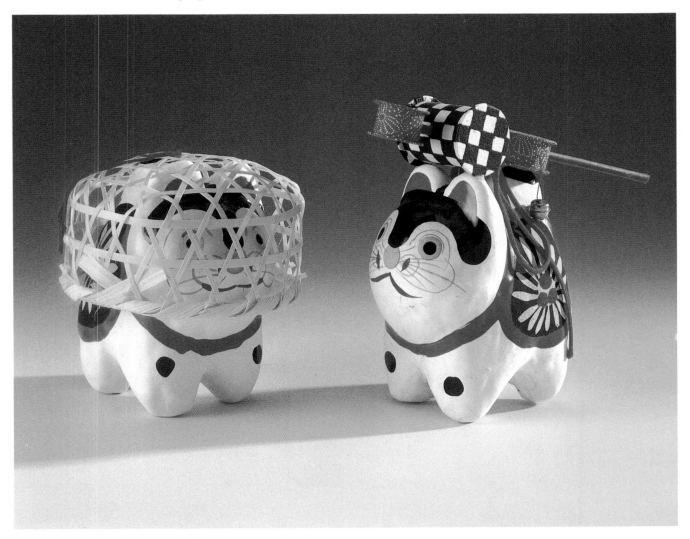

ed toy dogs were purchased after this event as protective charms. Today there are again two sturdy and stylized versions of the old Azuma dog being made: one carries a small drum on its back, the other a loosely woven basket over its head. The noise of the drum frightens away evil spirits, the basket prevents crying at night and clogged-up noses. Formerly the nose of the toy was pierced when the child had difficulty in breathing, and if the child had nightmares, the mother would call "*inuko, inuko*"—"doggy, doggy"

to drive away evil spirits.

The woodblock-printed book cover by Kuniyoshi (1797-1861) illustrates a contemporary version by Shunsui of an earlier story, *Hakkenden*, "The Story of Eight Dogs," and shows a *yakko* or servant wearing a jacket decorated with symbolic *inu hariko*. He is holding a baby, evidently protected by all the dogs on his coat. The toy is still a popular design for children's and young girls' kimono... an instance of the old protective symbolism turned into a decorative motif.

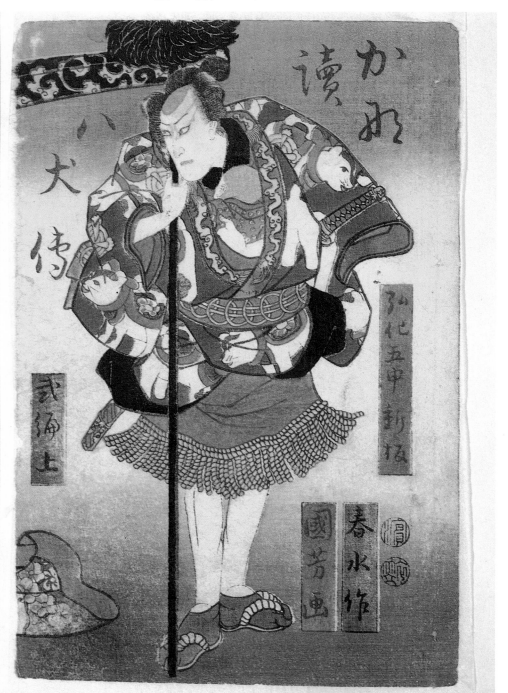

Like the Chinese, the Japanese eat snakes as a delicacy, and the scaly reptiles are still frequently prepared as a rejuvenating medicine. Drinkers who are after a special taste buy *mamushizake*, saké with a poisonous pit viper preserved in it. The Japanese calendar has a year of the snake, and there are days and hours (9 A.M. to 11 A.M.) of the snake. This jointed bamboo snake is sparse-

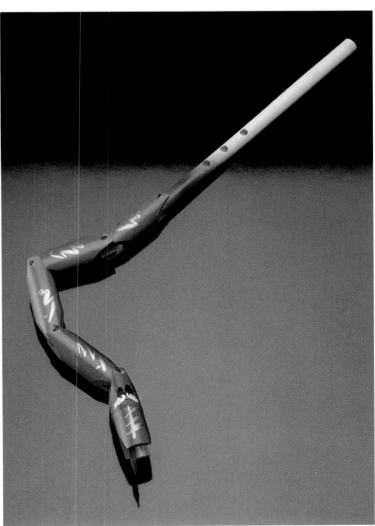

ly found nowadays around Japan; it seems to be a rare representative of the reptilian family. It makes an original and interesting plaything for children, due to the fascinating coil-and-recoil movement. A fierce woven straw example is found in the "Edo Nishiki" of 1773, but this type seems now to be extinct. The snake-toy is made of graduated pieces of bamboo wired together and painted green, and some varieties have a whistle in the tail. This whistle-snake is a harmless cousin of the rattlesnake!

Enoshima, connected to the mainland by a bridge, is a small island where a 106-meters-high escalator leads to a famous plant and flower reservation. Here the most important sanctuary, dedicated to Benten, is found. Benten is the goddess of love, beauty, music, and the fine arts. She is the only woman among the seven Japanese gods of good fortune, and is invoked on the day of the snake (the snake is a typical Kanagawa toy) for happy marriages and healthy children. Enoshima is surrounded by beautiful scenic spots with residences

of the rich and famous.

The attractive little couple shown is made of sea urchins and wood. Personages assembled from shells and other products of the sea are turned into toys and souvenirs by the wives of fishermen to earn a little extra money. The blowfish or *fugu* lantern of Kanagawa is famous throughout Japan. It makes an original signboard and a luminous advertisement for sushi shops.

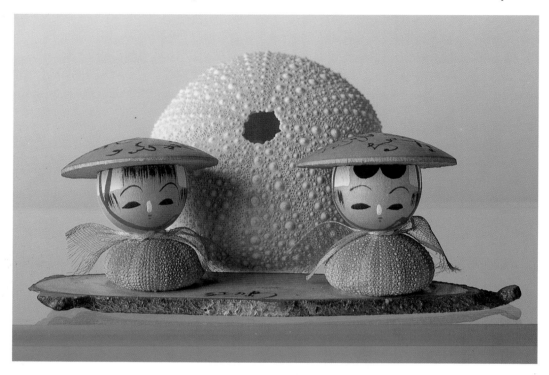

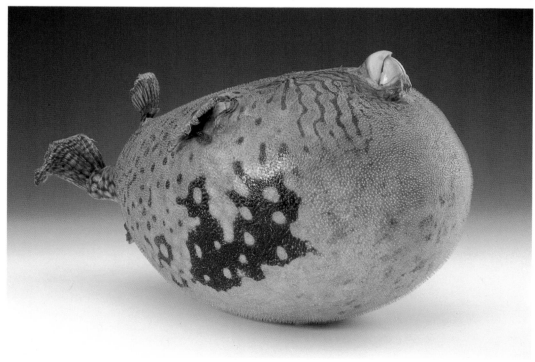

Chubu District

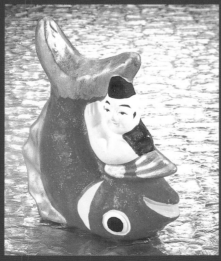

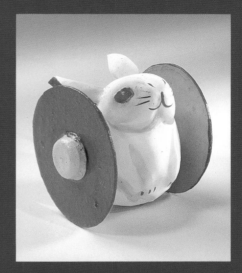

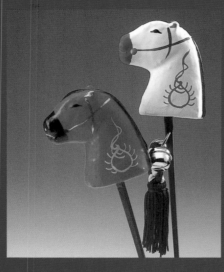

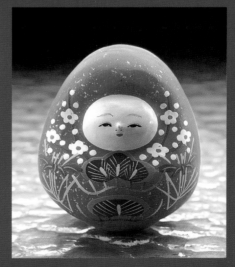

Prefectures of

AICHI	ISHIKAWA	SHIZUOKA
FUKUI	NAGANO	TOYAMA
GIFU	NIIGATA	YAMANASHI

TRIANGULAR DARUMA

SANKAKU DARUMA

CLAY, PAPER

NIIGATA PREFECTURE

Throughout Japan's history, the farmers were the exploited class. They were poor and necessarily inventive in using free materials in useful ways. Straw, bark, bamboo, seaweed, reed, vine, and various plant fibers are a few examples of nature's gifts which were put to good use by the people of the north. It is ironical to note that even when forests were filled with *hinoki* (cypress) trees, it was strictly forbidden to cut them

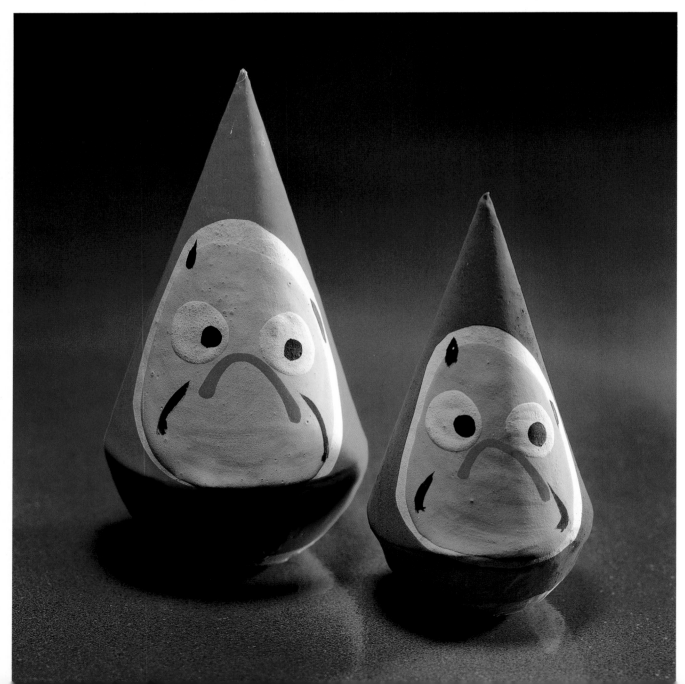

without permission on pain of death. There was then a sinister warning "a head for a tree ," a sentence lifted only in the Meiji era. Inventive farmers did get round the law, however, by weaving conical all-weather hats (*hinokigasa*) from the bark of these trees, for personal use, sale to travelers, and as a form of tax. Life was exceptionally hard for those who lived on and by the land. Using natural materials optimally for tools, living quarters, clothing and food somewhat alleviated their everyday condition. To face the long cold winter season, they made straw boots and *mino*, conical straw rain-and-snow capes. The *daruma* figures of Mizuhara in Niigata seem to be inspired by such functional clothing, and are unique among the *daruma* family for their original shape and whimsical expressions. They are, in fact, not triangular as named, but cone-shaped, and are formed by a simple paper cone in a rounded clay base. Like most members of the *daruma* clan, they always return to the upright position. A blue and red pair, of different heights, is purchased as new year luck bringers, while the previous year's set is given to the children to play with.

The happy, but somewhat tipsy wooden badgers are from Tsukioka. Badgers are usually represented with a *saké* bottle and an (unpaid) account book. With their lanterns and magic powers they can lead travelers astray, and even turn into water-kettles or speaking statues. More bent on mischief than real evil, some have been known to eat woodcutters' wives, or to smother hunters under their enormous scrotum! They are very fond of *saké*, and seldom pay their bills.

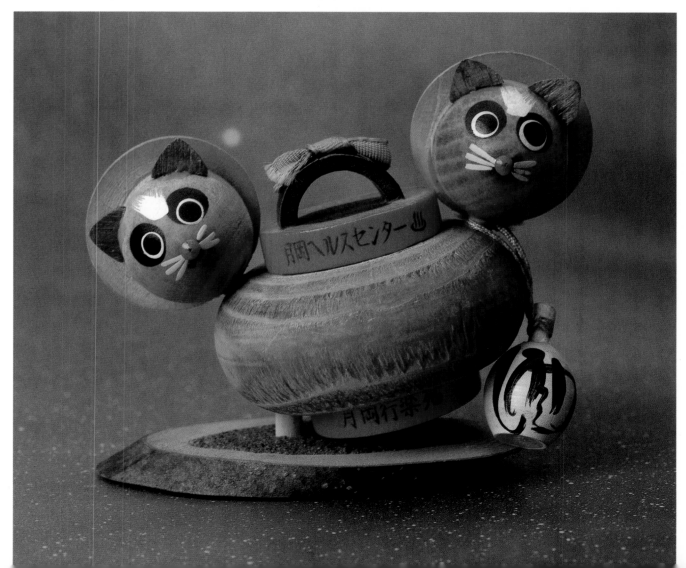

NOROMA DOLLS

NOROMA NINGYO

CLAY, BAMBOO, STRAW

NIIGATA PREFECTURE

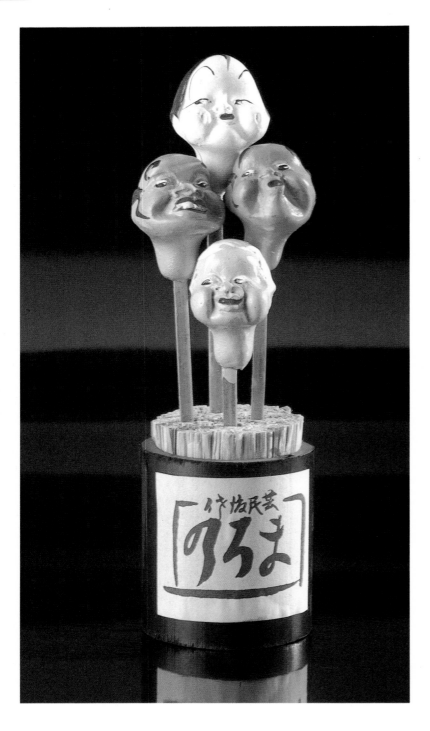

These miniature puppet heads are named after their inventor, Noromatsu Kambei, a puppeteer of early 17th-century Edo, who also wrote comic plays to go with his creations. They consisted of farcical, somewhat indecent interludes between the acts of serious dramas. The four best-known characters of Noroma comedies are the female puppet Ohana, with plump features and a flat nose; Busshi, a clever carver of Buddhist statues; Kinosuke, a good-natured simpleton; and the rich man, Shimo no Choja. Strangely, the production of Noroma plays and puppets died out completely in Edo, but took strong roots on the faraway island of Sado, the traditional place of exile for those who displeased the shogunate. There, any kind of entertainment from the mainland was immediately popular. At present, Sado Island is the only place keeping alive the traditional Noroma and Bunya puppetry. The toy heads are hand-formed by the "pinching" technique, and admittedly look rather comical. While the red, green, gray, and white colors of the faces are far from normal, they enable identification of the personages they represent. The base of tightly wrapped straw into which the heads are inserted by pointed bamboo sticks is still used by contemporary doll-makers when working on doll heads. The Noroma *ningyo* are now sold as typical souvenirs of Niigata Prefecture in general, and Sado Island in particular.

Gathered in autumn, stripped of its bark, and then naturally bleached in hot springs, *akebi* vine is a strong and beautiful material from which many useful and decorative items are woven.

One of the most original toys is the dove cart first made by Anshin Kawano about 140 years ago. Production stopped when he died, but was resumed at the beginning of this century. The *hato-guruma* is a souvenir of the Nozawa hot springs region, and also of the Zenko-ji, or Good Light, Temple in Nagano City. As many pigeons flock around the temple, they perhaps furnished the model and inspiration for this toy. It is artistically shaped, runs easily,

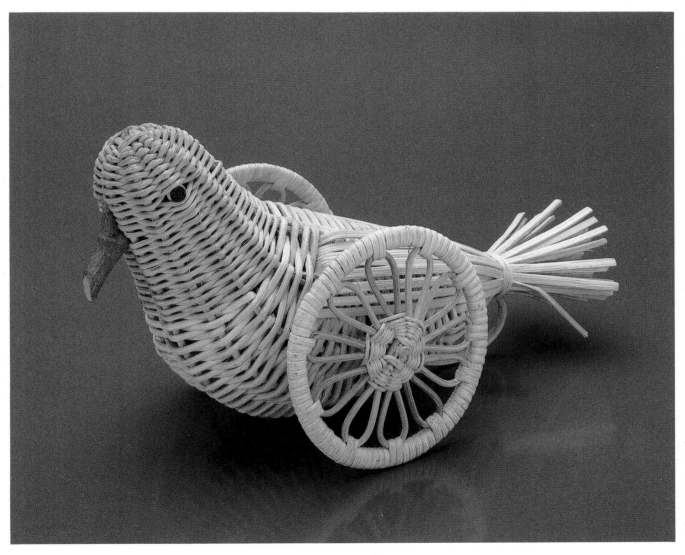

and has a beak made of a well-cut twig. It promises its owners the safety, good health, and happiness of peaceful doves.

An amusing souvenir of Zenko-ji Temple is a happy little couple made of nut halves, sitting in a *waraji* or straw sandal. *Waraji* were formerly worn by pilgrims walking long distances to temples. On arrival, frequent prayers were those asking for a lasting union, or for a compatible marriage partner, one who would fit as perfectly as two identical nut halves put together!

Another lucky charm of *akebi* vine, made specially for children, is a cone-shaped "Chinese horn" incorporating a bamboo whistle. Such horns were often blown by itinerant medicine peddlers to announce their arrival to villagers. Some say it was also used as a measure!

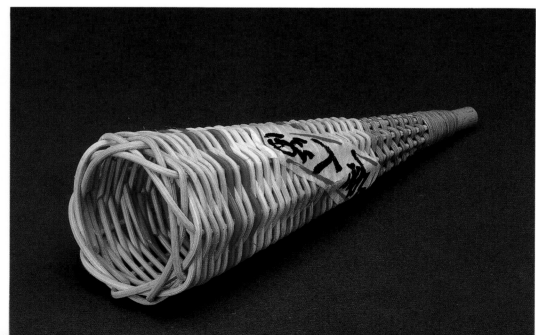

Throughout Japan's history, *sumi* or charcoal, was a commodity of great importance as a warming and cooking agent. It was usually prepared by poor people of isolated villages, who carried bundles on their backs for long distances, to sell from door to door in the cities. The smoker's *hibachi*, the sword-smith's forge, the large *hibachi* for warming rooms and boiling water and the portable hand-warmer, all were fueled by charcoal when the people were rich enough to afford it. The region of Suwa in Nagano Prefecture is known for producing good charcoal. Aesthetic conventions govern the shape, aspect, and quality of *sumi...* the beautifully shaped white twigs and specially cut pieces for the tea ceremony are such examples. A piece of charcoal is traditionally used with other symbolic decorations at the new year season. It is a sign of longevity because it burns very slowly, and also means "may you dwell in the same place for many generations." In prosperous shops it was customary to bring a small *hibachi* and a smoking set to customers during the cold season. The charcoal *daruma*, unique for its material, is sold at Shinano Kokubun-ji Temple as a charm for long life. The face is cut from a cylindrical piece of charcoal and painted bright red. The features are added with black and white paint. A *daruma* to bring luck and warmth to buyers!

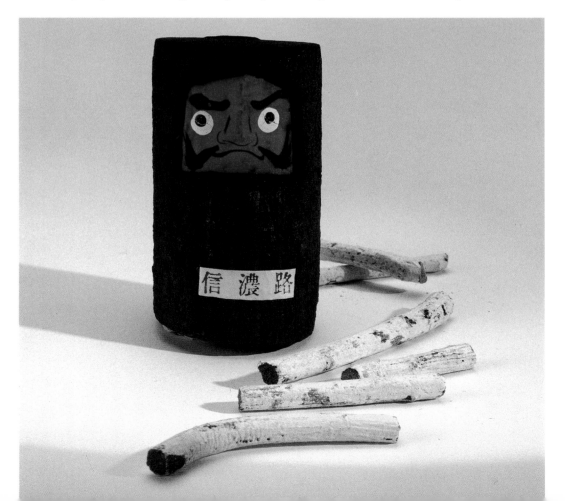

FIVE-COLOR DARUMA

GO-SHIKI DARUMA

PAPIER-MACHE

YAMANASHI PREFECTURE

In Kofu, once a renowned silk-producing town, the five-color *daruma* have been sold since the 17th century as protective charms for all aspects of the silk industry, ranging from the initial silkworm raising to the final weaving of the thread. Another charm has five clay bells strung from a branch in the shape of a bow (*yumi-hari suzu*), each decorated with a different colored strip of paper. There are three versions of the stoty

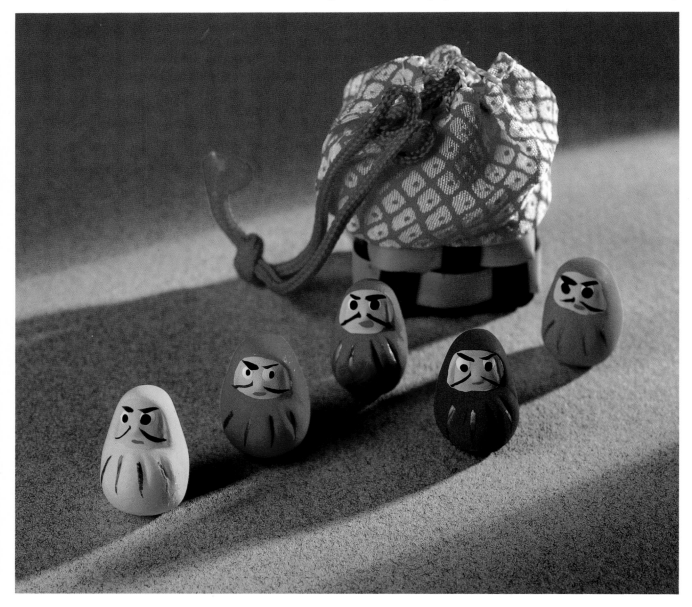

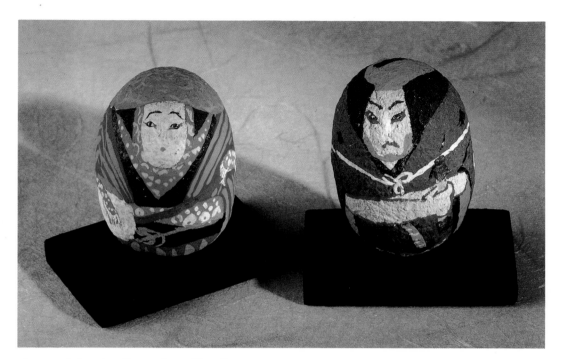

that explains the five colors. The first says that they are symbolic of the gift of coarse silk of five colors offered to the Shinto gods. The second that they relate to the words of Buddha, "One flower opens to five petals and bears fruit according to its own nature." The third simply says that they represent the five primary colors used in silk dyeing—although the five colors are not always the same from set to set. The five little *daruma* figures, wrapped in a twist of paper, are kept in a tiny woven basket no larger than two-by-two centimeters!

Sometimes five-color *daruma* and other personages are found painted on *mayu* or silk cocoons. Shown are two *mayu* delicately painted with figures from the entertainment world, a kabuki actor and a woman *shamisen* player.

Also from Yamanashi Prefecture, the white papier-mâché *daruma* with a smaller mustached version painted on his body, represents a father and baby son. The mustache symbolizes the hope that when the son is older, he will rise to a better position in life than his father. It is of course, an open question what the father thinks about this toy when it is given to his son!

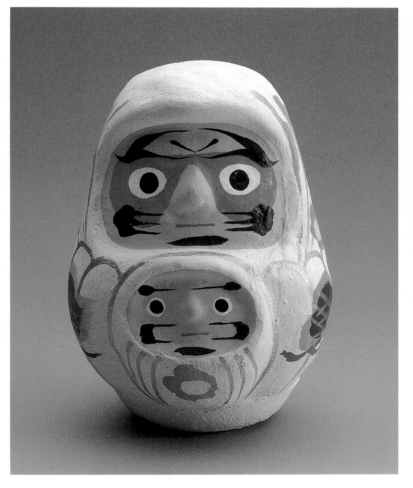

HARE ON WHEELS

USAGI-GURUMA

PAPIER-MACHE

SHIZUOKA PREFECTURE

Samurai were always expected to be frugal in their living habits. Food, dress, emotion, and expenditure were (or should have been) of the utmost sobriety and in direct contrast to the way of life of the rich Edo-period merchants. After the Meiji restoration when the samurai class was abolished, many former warriors were left without means; to make a living they turned to toy-making, a more genteel alternative to commerce. Merchants, who did not themselves produce anything, were not respected, as they earned money by handling, buying, and selling things that others (farmers and craftsmen) had produced. This

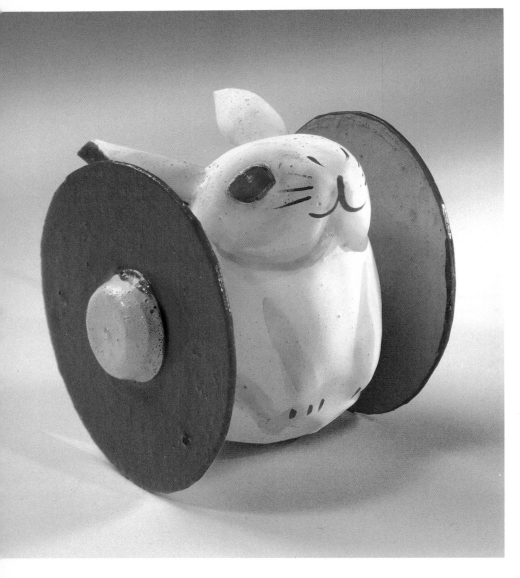

lucky white hare was first made by an inventive do-it-yourself samurai from Hamamatsu, who so found a use for his old calligraphy paper. This samurai was not, however, well acquainted with mechanical devices, for instead of the wheels turning, it is the acrobatic hare that turns round the axle holding the two immobile wheels together. All white animals were considered especially auspicious, and the white hare is also associated with the moon, where it pounds *mochi* (sticky rice paste), symbolic of longevity and a happy new year. Since the Meiji restoration this white hare on wheels has been made by three successive generations, descendants of that first frugal samurai!

There is another wheeled papier-mâché toy with a mobile head in the Hamamatsu repertory, a bird dancer complete with feathers, known as *tori* (bird) *kagura. Kagura* is the sacred music and dance performed at Shinto festivals in homage to the gods. This fanciful cart has four wheels which really turn!

KUBI NINGYO

CLAY, STRAW

SHIZUOKA PREFECTURE

This small collection of doll heads planted in a straw bundle is a well-known souvenir from Shimizu. Although they are all different, they are collectively called "Ichiron-san" or Mister Ichiron after the Edo-period greengrocer who first made them to supplement his meager income. The humorous heads were so popular that production became a cottage industry and has lasted to this day. The sixth generation still actively produces the heads, true to the tradition of the forefather. The characters are based on mythical beings, folk heroes, famous warriors and actors. These doll heads are not meant to be used to form an entire doll, but are presented in a tightly tied and cut straw bundle, an accessory still used by all doll-makers when modeling and painting the heads of their dolls, prior to dressing them.

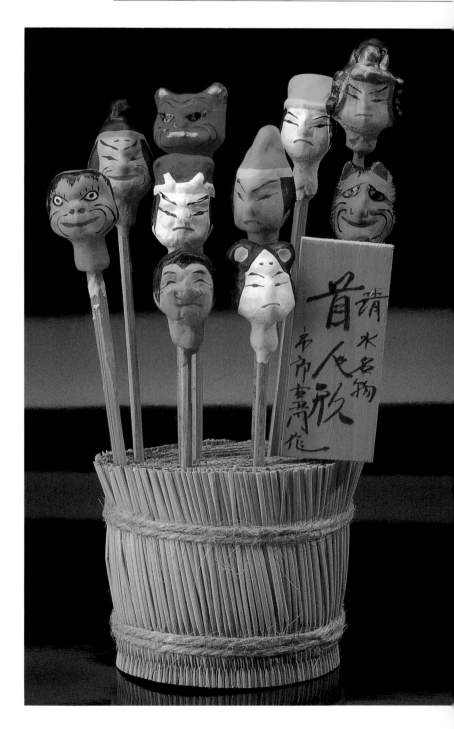

SPINNING MICE

MAWARI NEZUMI

WOOD, BAMBOO, STRING

AICHI PREFECTURE

Puppets and articulated dolls have a long history in Asia, for they were introduced to Japan from China, Korea, and other countries during the ninth century. However, rudimentary puppets or *kugutsu* (the earliest word for puppet) also existed in Japan prior to this date. The string and rod mechanism shown here must have existed before the Edo period, but it became popular at that time through the many peddlers and *kairaishi*, itinerant puppeteers who crossed the countryside, visiting isolated farms and villages. Several woodblock prints of the Edo period show actors or puppeteers playing with puppets manipulated by this simple system. Here, three cone-shaped mice with red tails make a squeaking noise and spin round when the transversal wooden piece, to which the strings are attached, is moved up and down. The principal rod is made of split bamboo, and the mice (of an unknown species) are painted red, white, pink, and black. This is a pleasant plaything for all ages!

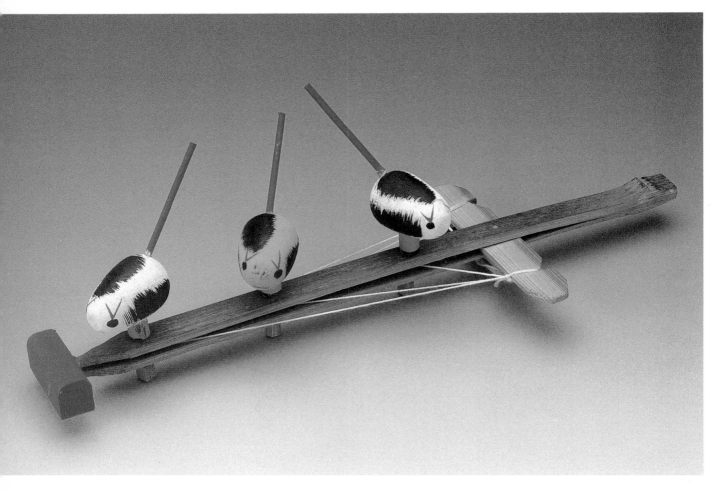

PAPIER-MACHE, WOOD

AICHI PREFECTURE

These two well-modeled heads with small ears and gentle expressions come from Ryusen-ji Temple in Shidami. They are mounted on bright green sticks; the red horse makes a rattling sound and the white one is decorated with a bell attached to a twisted silk cord and tassel. The heads are painted with the Buddhist *tama,* or flaming pearl, which grants all wishes. Ryusen-ji is dedicated to one of the rarest emanations of the Goddess of Mercy, the Bato Kannon, identified by the horse head embellishing her headdress. The temple has other horse amulets which were formerly sold as protective charms for horses and cattle, but have now become general good luck bringers and children's toys. Horses are primarily boys' toys, and are symbolic of virility, courage, and endurance.

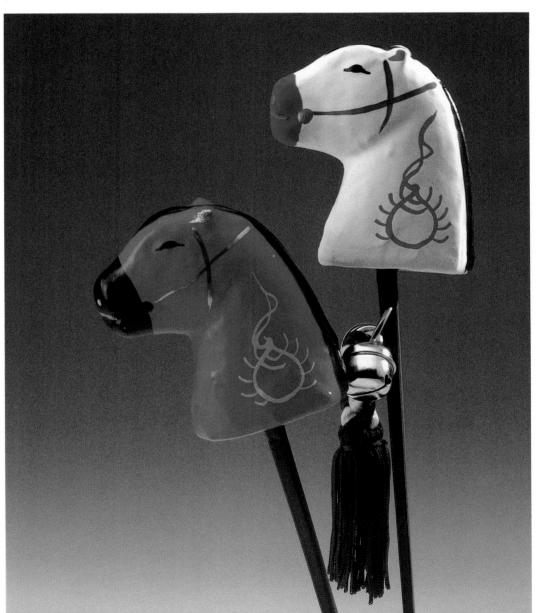

TICKING DRUM

DENDEN TAIKO

PAPER, WOOD, BAMBOO

AICHI PREFECTURE

Made of simple materials and painted with primary colors, this ingenious little toy is a forerunner of modern gadgets, showing the Japanese love for intricate mechanisms and a thorough comprehension of cause and effect. When blown, the air escaping from the bamboo whistle makes the pleated paper flower rotate, and with it the paper figure fixed to its axis. The figurine holds threads with attached wooden beads, which beat on the stretched paper of the standing drum when the revolving doll twirls around. *Den-den* refers to the sound made by the beads striking the drum. Children were encouraged to play with noise-making toys, as noise attracts the attention of protective gods, and frightens away evil spirits. The drum is decorated with a jewel, symbol of prosperity, and a peach, symbol of fertility and longevity. This lucky drum-whistle is sold as a souvenir of Nagoya and Inuyama. Totally hand-made, it is comparatively rare.

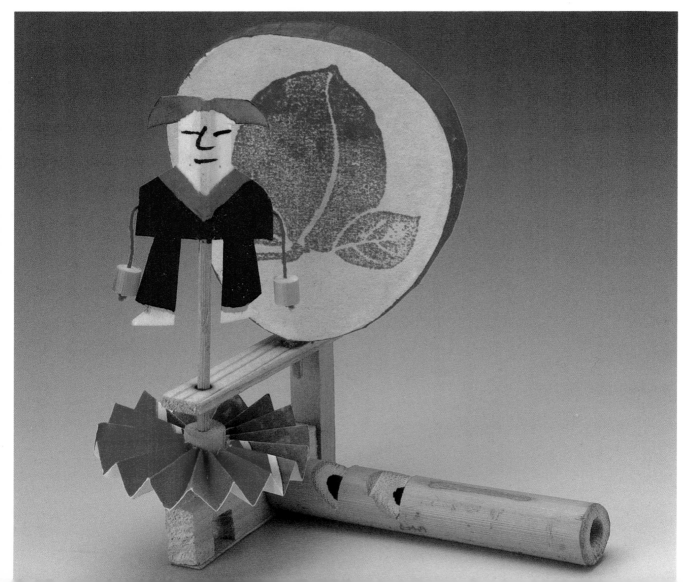

This charm is based on one of the oldest doll types of Japan, the Hoko or heavenly child, the body of which was made of a single stitched-up piece of white silk. The doll served as a decoy for all evil which might possibly strike the child it guarded. A red monkey doll was more specifically efficient in attracting and capturing the spirit causing smallpox, as this spirit had a predilection for the color red and was afraid of monkeys. The charm is still sold to protect children from traffic accidents and to ensure a safe delivery. It is also hung in cars as a mascot. The dangers have changed, but the symbolism endures.

CATFISH SUBDUER

NAMAZU OSAE

PAPER, WOOD, SILK

GIFU PREFECTURE

Gifu Prefecture is known for its nine festivals which feature short puppet plays presented on large, ornate floats or *dashi*. The large puppets, known as *dashi karakuri* or trick dolls, are string-manipulated from the inside of the floats by up to six puppeteers, and perform extremely difficult actions. This mobile toy, first made during the Meiji period, represents in miniature the Dogaibo float of the Hachiman festival of Ogaki, held on 15 and 16 May. It illustrates the saying "*hyotan namazu*" or "catching a catfish with a gourd," which means attempting the impossible. The toy protects against earthquakes, said to be caused by a giant subterranean catfish when it wriggles and shakes its tail. A stone enclosed at Kashima Shrine

in Ibaraki Prefecture is thought to be the petrified sword of the gods, which goes to the center of the earth, and keeps the catfish in place. The toy has a simple mechanism. When strings attached to sticks holding the figures are pulled, both revolve; the man turns round to catch the catfish, which escapes, turning in circles. It is an original but flimsy plaything, not strong enough to take much handling. The man holds a (very) tiny *hyotan* and wears a baggy red silk cap. A red sash accentuates a black paper jacket, over white and gold striped *hakama* trousers; the catfish is made of black paper, the base of brown wood and red paper. The features of the man and the fish are carefully painted on rectangular wooden blocks.

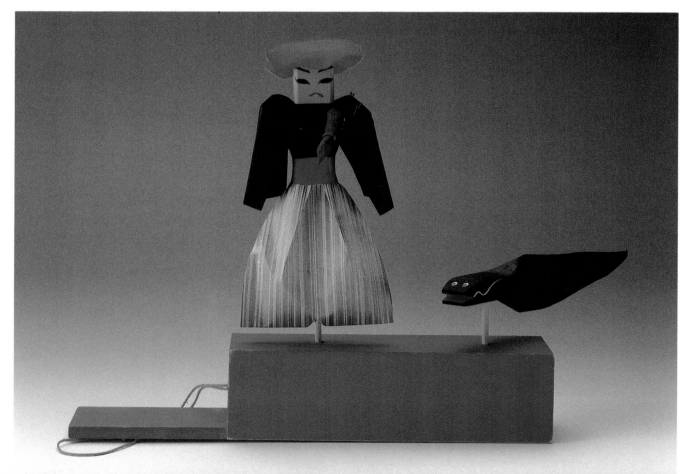

Both the sea bream and the carp have auspicious connotations, and are frequently found in Japanese arts and crafts. Most red fish toys are usually considered to represent the sea bream or *tai*, but early versions of this toy are called "*koi*" or "carp" and derive their symbolism from ancient China. The carp is one of the principal symbols of the Boys' Day festival, and at that time huge carp made of paper or textiles are flown from poles set in the gardens of houses where there are small boys. There is one for each boy, graded in size to the age of the children. The carp symbolizes strength, perseverance, and courage in adversity, for this fish fights its way upstream, against the strongest currents. A carp toy or souvenir is the perfect present for a young boy, who must try to emulate all the manly virtues of this kingly fish. An old Chinese legend says that a carp passing the Lung Men rapids on the Yangtze River turns into a dragon! Shown is the legendary Japanese boy Hercules, Kintaro, who successfully captured a gigantic carp while swimming under water. It seems he has not lost his hat or his dignity in the struggle! The toy is a typical Toyama souvenir.

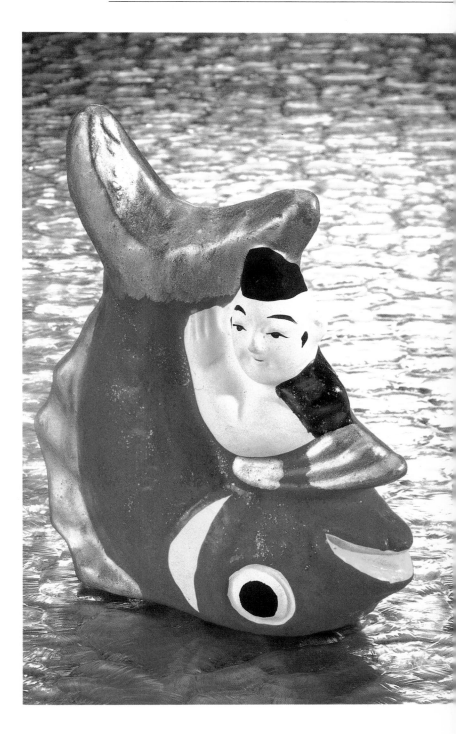

HACHIMAN TUMBLER

HACHIMAN OKIAGARI

PAPIER-MACHE

ISHIKAWA PREFECTURE

This tumbler-toy represents the Emperor Ojin as a child, wrapped in his imperial and protective red baby-clothes. Legend says that his mother, the famous and bellicose Empress Jingu, delayed his birth until she had conquered Korea by wearing a heavy stone tied against her body. The toy originated at the Hachiman Shrine of Kanazawa, where the Emperor Ojin was deified and worshipped. The first figure was reputedly made by an old man who had a special reverence for the god of war, Hachiman. It is decorated with the *sho-chiku-bai* or pine-bamboo-plum motif, a well-known auspicious new year's symbol. Since the 18th century, these toys have been given to sick people as an aid to recovery, and to married couples as a wish for healthy children. While in Shinto religion Hachiman is deified as the god of war, Buddhism sees in the figure *hachi* (eight) the eight just ways of going through life: right seeing, hearing, thinking, speaking, acting, living, walking, and final enlightenment.

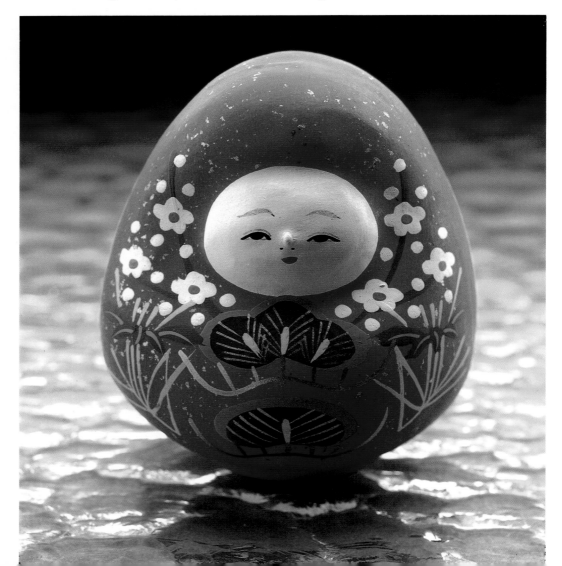

MOUSE

NEZUMI

WOOD, BAMBOO

ISHIKAWA PREFECTURE

In 1830, there was a great famine in Japan, due to the failure of the rice crop, Japan's staple food. This little mouse, trying to eat from an empty dish when the bamboo spring is pressed together, was a humorous if sad caricature of lean times. Its body is made of wood charred to a dark brown tint, the head and tail are mobile, dipping down when the mouse tries to eat. It is altogether an original and well-made little toy. The "Edo Nishiki," 1773, shows a furry animal with bushy tail (fox or raccoon?) with the same spring mechanism. The principle is still used in other playthings, such as lion heads with mobile jaws and fierce expressions.

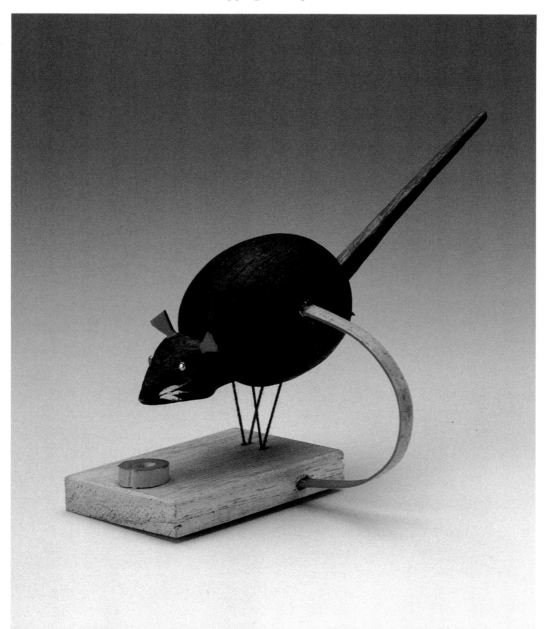

HARE POUNDING MOCHI

USAGI

WOOD, TEXTILE

ISHIKAWA PREFECTURE

Although this popular mobile toy from Ishikawa Prefecture is cut from natural wood, it represents the legendary white hare on the moon pounding a very sticky rice paste, known as *mochi*. The hare is associated with the moon, where it prepares this delicacy, traditionally eaten at the new year. (A *mochi* cake is round like the full moon.) The symbolism was borrowed from the Chinese, who thought that the hare on the moon was preparing the elixir of longevity with mortar and pestle... and that the hare was white because it was so old. The "Kojiki" ("Records of Ancient Matters"), one of Japan's oldest historical accounts (also borrowed from China) mentions the legend of the white hare of Inaba who is cured by the Deity-Great-Name-Possessor and in turn, helps him to obtain a bride. In antiquity, all-white (albino) animals were considered especially auspicious for the ruler and presented to the emperor, who liberally rewarded finders. The (brown) hare of Ishikawa has red ears and is dressed in a blue vest and a red apron. It has a simple string mechanism, pulling the arms holding the pestle up and down. The toy is given to children at the beginning of a year to ensure health and happiness. As one of the animals of the oriental zodiac, it is an extremely auspicious sign to be born under.

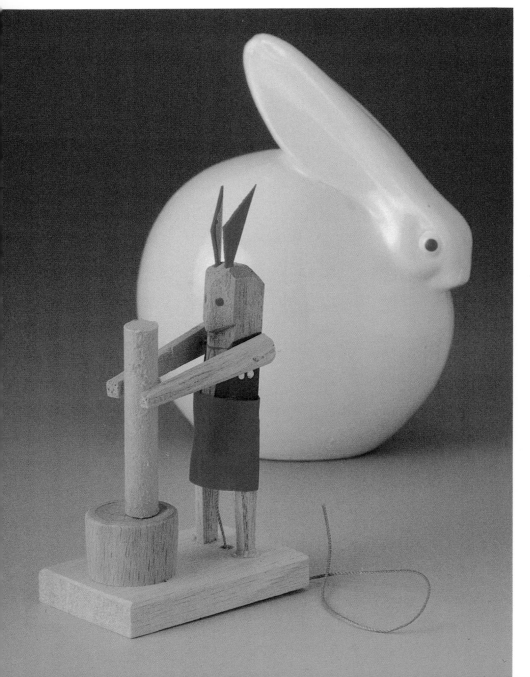

KAGA LION HEAD
KAGA SHISHI-GASHIRA

WOOD

ISHIKAWA PREFECTURE

The lords of Kaga were the richest nobles in Japan after the Tokugawa Shogun. They were "outside" lords, meaning that they had been hostile to Tokugawa Ieyasu prior to his victory at the battle of Sekigahara in 1600. As they were so powerful they had received an annual income of 1,300,000 *koku* of rice to keep them friendly. A *koku* is five bushels, enough to feed one person for a year. This allowance, however, did not keep them from soldierly training. A toy with an interesting story, this lion head is a miniature of a large float originated by a lord of Kaga, to be carried at local festivals.

The festivities were disguised military maneuvers, for the dancers accompanying the float made use of the occasion to train for and exercise the martial arts. In the Edo period, these were strictly forbidden to all save the samurai class. The lion's head is carved from natural wood, the jaws are mobile, and the eyes and teeth gilded. It has a flax mane and holds a wooden sword between its teeth. The head exists in many sizes, and is certainly more of a sculpture than a toy. Contrary to custom, this well-made carving is signed by its maker and has its own calligraphed wooden box.

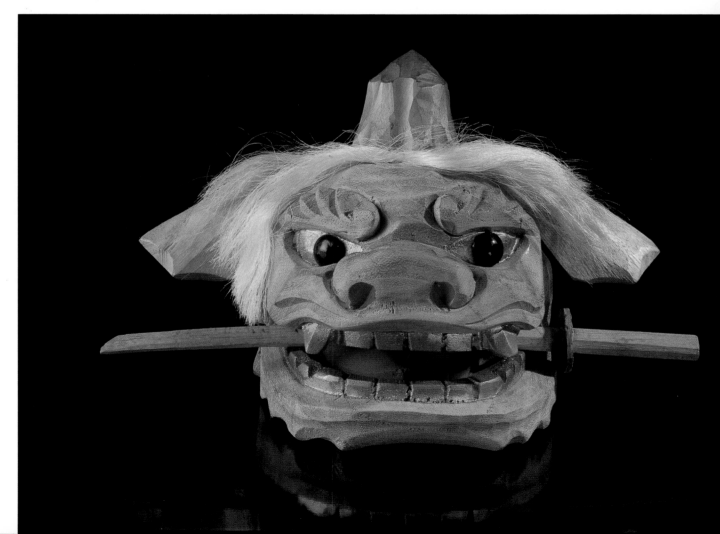

BAMBOO DOLL

TAKE NINGYO

BAMBOO

FUKUI PREFECTURE

Many poems and books have been written about bamboo, one of the most intriguing, artistic, and useful plants. Picturing bamboo is the first exercise for ink painters. This beautiful and versatile material is still in use in everyday life, and the doll and toy repertory would not be complete without at least one bamboo doll, a specialty of Fukui Prefecture. The dolls are made of pieces of natural and tinted bamboo, split, cut, and assembled to take full advantage of the natural curves to form head and clothing, and to give the impression of graceful or violent movement. Subjects from history and mythology, kabuki actors in famous roles, and dancers of well-known dances such as the Awa *odori* (Awa dance) here represented, form the greater part of production. The song that goes with the Awa dance says:

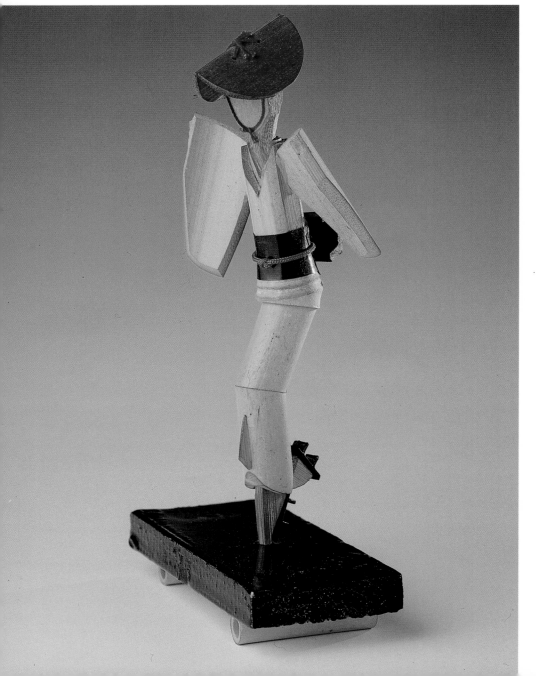

> Since we dancers and you spectators are both crazy, you're crazy if you don't dance!

The little monk with the huge pestle and small mortar is crushing seeds into a paste or powder which will feed many mouths, as his own enlightened mind will later nourish the spirit of many people. It is an older piece which comes from Eihei-ji, the famous Soto Zen temple founded by Dogen in 1244. Dogen not only wrote a spiritual treatise which is now designated as a National Treasure, but also compiled

a more prosaic work catering to daily needs entitled "Instructions for the Zen Cook." As there are currently 150 young monks or *unsui* practicing *zazen* at Eihei-ji, most souvenirs represent novices sitting in a food bowl, or working with a pestle to prepare the prescribed Zen food, while polishing their minds. The pestle of our bamboo monk has been patiently inscribed with diminutive calligraphy reading:

A man who spends his life refining his mind in order to communicate his thoughts to other people is worthy of respect.

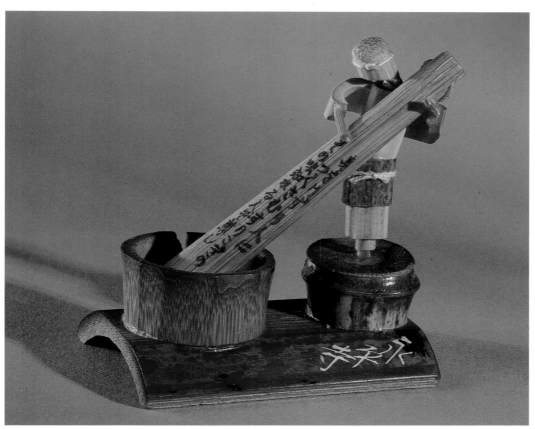

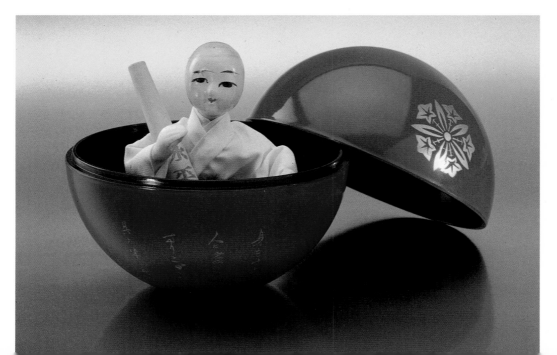

EGG DOLL
TAMAGO NINGYO

EGG, TEXTILE

FUKUI PREFECTURE

When touring Japan, it is an amazing sight to see country people boiling eggs in hot springs. If it is sulfurous water, they come out tinted a greyish-black color. An elaborately dressed egg with a painted face is certainly one of the most unusual folk toys ever made! With a simple black-lacquered base, it is a souvenir and lucky charm of Obama City. At Myotsu-ji Temple the doll is also sold as an amulet; it is fixed to a special base of wood from ancient temple buildings and marked with a burned-in seal "old material, from a treasure of the country." The wood from holy buildings adds to the talismanic value, and when wearing a red wig, the dolls are protective charms against illness. They are always dressed as kabuki actors, in beautiful brocade costumes adapted to the egg's shape. The face, suggesting a kabuki actor's make-up, is painted on the middle part of the egg. The two dolls shown represent the famous "Shakkyo" lion dance, in which an old lion (with white hair) gambols with his young son (with red hair) in the mountains. The performance is characterized by much stamping and shaking of the wigs, symbolizing the lions' manes. The dance also relates to the legend of the *kara-jishi* or Chinese lion who pushes his cubs over a deep precipice to test their endurance until only the strongest is left. The legend and the egg dolls are perhaps connected to the curious festival of the Kinumine Shrine located in adjacent Shiga Prefecture. Here, on the first Sunday in May, an egg-shaped *mikoshi* or portable shrine is lowered down a steep hill 600 meters long with a vertical drop of 150 meters.

Kinki District

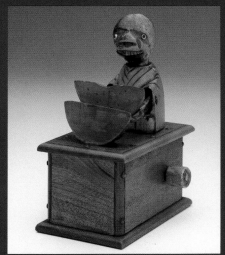

Prefectures of

HYOGO NARA WAKAYAMA
KYOTO OSAKA
MIE SHIGA

DRUNKARD

SHOJO

PAPIER-MACHE

SHIGA PREFECTURE

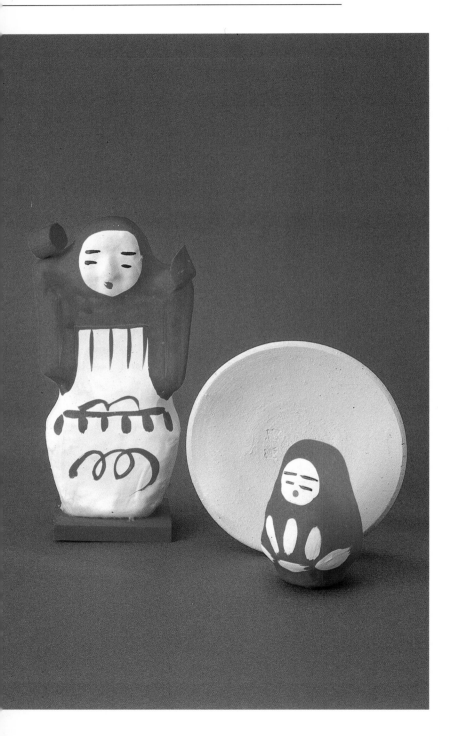

This happy drinker is also called an "orangutan" doll, and represents a *shojo* or drunkard. *Shojo* are legendary water spirits living by the seashore who are overly fond of saké. They have long red hair and are often represented dancing round a huge saké jar holding a lacquered cup and bamboo ladle, or sleeping against the evidently empty jar. Wicked fishermen were said to lure these gentle creatures with the irresistible saké, and when they were drunk and sleeping, captured and killed them to make a costly red dye from their hair and blood. Toys painted red and dolls with red hair are thought to be very efficacious in driving away the spirits causing illness in general and smallpox in particular. A variant version says that the god of smallpox likes the color red so much that he will leave a sick child and move into a red doll or toy which can then be destroyed. The *shojo* of Kusatsu, holding cup and ladle, was traditionally given to newborn babies as protection against smallpox. It is red, and on the white saké jar are painted red and blue decorations. Formerly a self-righting tumbler toy (recovery from illness), the present version is fixed to its wooden base, but a small *daruma* doll and a clay saké dish are always sold together with the *shojo*. The *shojo* is promised a drink if he cures the illness. This rustic toy dates from the Edo period, and its production was the hobby of the innkeeper of the Kawabata-ya, an inn along the great Tokaido Road between Edo and Kyoto. It was an agreeable business policy to sell saké and souvenirs, both with potent healing powers.

SARU

WOOD

SHIGA PREFECTURE

This summary figurine, carved from plain wood, comes from the Hiyoshi Shrine in Sakamoto and is a charm for fertility and recovery from illness. The name of the shrine in the form of a burned-in seal, is found on the back of the monkey. It is a smiling little personage, proudly wearing a high, pointed cap resembling a *Sambaso* dancer's headgear. The monkey has always been a popular animal in Japanese lore, and its sculptured image is as old as Japanese history, dating back to the many excavated clay *haniwa* figures from the Kofun or Tumulus period (250-552). Even so far back, it seems to have been invested with fertility-giving and guardian-from-evil powers, and its presence was deemed necessary in afterlife. The monkey was believed to be feared by the spirits causing illness to humans and animals, and its image in many forms was often found in houses and stables of the countryside. In the villages, children were given small, stitched cloth monkey amulets called *kukuri-zaru* to protect them.

DIVINE BIRDS OF ISE

ISE KAMI-DORI

WOOD

MIE PREFECTURE

The Great Shrine of Ise, dedicated to Amaterasu, the Sun Goddess, is the principal shrine of Shintoism, the indigenous religion of Japan. Here is honored the mirror, one of the three regalia reputedly given by the Sun Goddess to Jimmu Tenno, the first emperor of Japan (ca. 660 BC). Since the reign of Emperor Temmu (r. 672-686), the shrine has generally been rebuilt every twenty years for reasons of ritual purity. Although not allowed to enter the inner precincts, since the shrine's foundation, millions of pilgrims have flocked to Ise and washed in the Isuzu River as an act of devotion and purification. Shinto is an animistic religion seeing omnipresent gods in all aspects of nature, so the rooster who crows at sunrise and drives away darkness and the forces of evil is a specially apt symbol of Ise. The *torii*, a gate marking the entrance to every Shinto shrine, large or small, is the symbolic perch from which the rooster greets the rising sun, emblem of the Japanese nation. Souvenirs of Ise, the rooster and hen, are carved in the one-knife, manner with clean, simple planes and sober touches of color. Amulets bought at Shinto shrines on the day of the rooster are thought to be particularly efficacious protectors and guardians of the home.

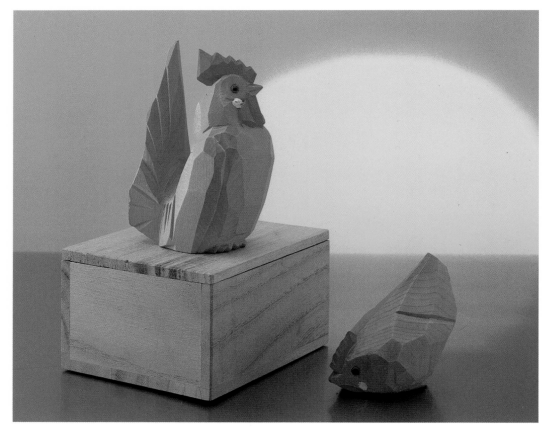

All kinds of small creatures painted red are sold at Ise as charms and protective playthings for children. The color red is often used for toys because it keeps evil spirits away... but what makes these little molded animals particularly attractive is that they are all ingeniously conceived to move in some way. The tortoise and the ladybird have a simple built-in self-winding mechanism, consisting of a spool, thread, and rubber band which allows them to run short distances when a thread with an attached ring is pulled and allowed to rewind. The tortoise has always been known as a symbol of long life, and at temples and shrine festivals small live tortoises and other animals, fish, and insects are sometimes sold as pets, or to be freed as an act of merit for future life. The moving tortoise at the end of its string is inspired by a curious way that small live tortoises were carried when sold as pets for children. They were tied with an intricate string harness, leaving head and legs free to move, rather like a dog on a leash.

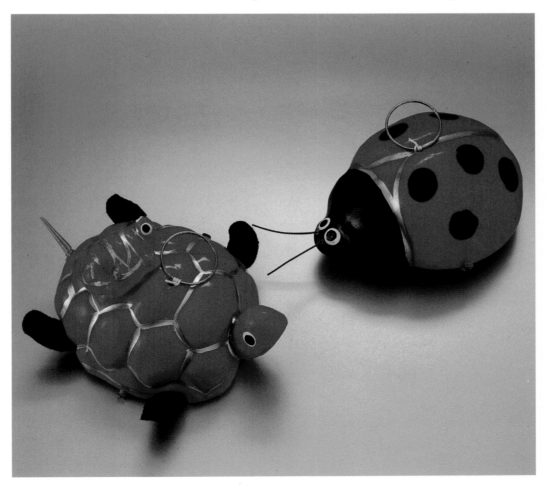

UJI TEA-PICKER

UJI NINGYO

TEA-BUSH WOOD (Camellia thea)

KYOTO PREFECTURE

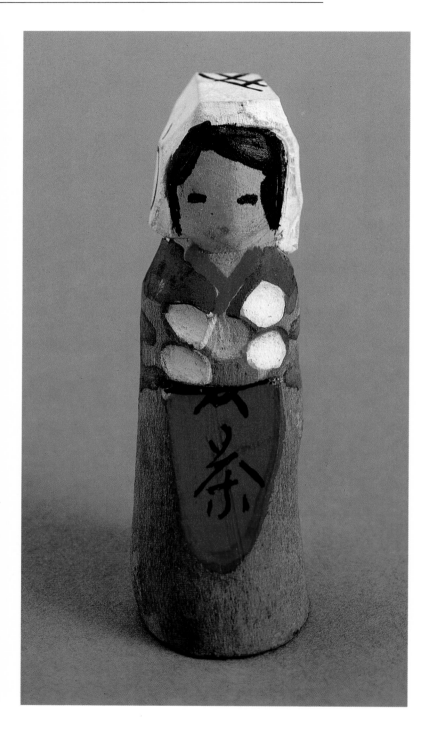

Uji is famous for the best tea in Japan, and in particular for the *matcha* or powdered green tea used for the tea ceremony. The typical souvenir of the district is a somewhat rustic and unassuming cousin to the Nara doll, made of tea-bush wood and carved in the one-knife, or *ittobori*, manner. The making of these dolls began as the hobby of Kanamori Shigechika (1583-1656) who had been the daimyo of Ida, but retired from office to become a priest and tea ceremony master. The tea-bush is a small shrub, so the figures are restricted in size and detail to a strict minimum. The doll, representing a woman tea-picker, is painted in primary colors, but some part of the tea-wood is left uncolored. The words "tea" and "Uji" are sometimes painted on the lady's cap and apron. History recalls that in 1843, an Uji doll made by Gyuka was presented to the 12th Tokugawa Shogun, Ieyoshi, by Tsumura, the lord of Ise and magistrate of Kyoto, as a typical product of Uji.

OHARA-ME

WOOD

KYOTO PREFECTURE

Although Kyoto, the imperial capital from 794 until 1868, is extremely rich in many kinds of sophisticated dolls such as the Gosho, Kamo, Saga, and *hina* dolls, it is surprisingly poor in folk toys. This was perhaps due to the refined taste of the courtiers and inhabitants of this elegant old city, who set the fashion for the Japanese elite and rich merchants. As folk toys there are two interesting examples from the working class, which show original and picturesque aspects of the customs of the time: the Uji tea-picker and the Ohara-me. The Ohara-me were the women of Ohara, a small village in the northwest suburbs of Kyoto, who came to sell their garden produce of vegetables and flowers, bundles of firewood, and all kinds of wooden implements at the Kyoto markets or from door to door. They were known for their industry and friendliness and their custom of carrying the most diverse objects on their heads, an unusual practice in Japan, where most burdens are transported on the back or with the help of shoulder poles.

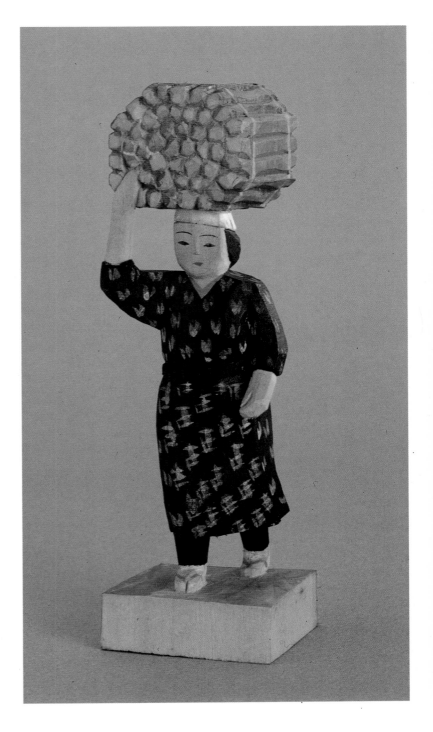

WRITING-BRUSH DOLL

NINGYO FUDE

BAMBOO, SILK THREAD, HAIR

HYOGO PREFECTURE

This unique brush has been made since the 16th century in certain isolated villages of Hyogo Prefecture. It is an original and beautifully finished article, made in the same way as the *itomari* thread balls. Perhaps it was invented by someone winding silk threads, leftover from spinning, round a plain bamboo brush to give it a good grip and extra selling appeal. There is an extraordinary variety in the wrapping patterns and color combinations, so that no two brushes are ever alike. An additional feature is the sur-prising little doll hiding in the hollow shaft of the brush, which appears when the brush is held vertically, in the correct position for calligraphy and painting. The brush is usually sold as a set, in a box containing a second smaller and slimmer brush without a doll. The brushes are brilliant little gadgets *avant la lettre* (i.e., before the term "gadgets" was coined) and are bought more as collectors' items than for intensive use...although using this brush combines work and play!

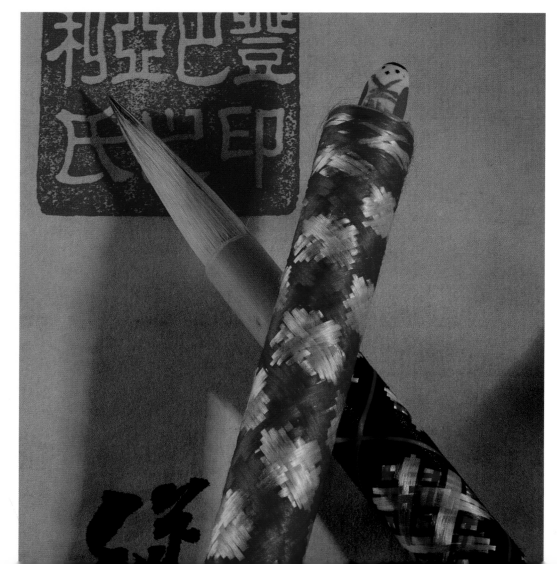

This light, original, and handmade doll figure from Shuzen-ji, a Buddhist temple in Hyogo Prefecture, forms a charm for the good luck and safety of girls. Rings of various sizes and colors are put over a slim bundle of natural straw, topped by a flat, painted head. The rings form the kimono pattern and can be arranged to form many designs. They are very delicately woven and are all different. Straw figures have been used for fetishistic purposes since ancient times. They were placed alongside roads to absorb epidemics, and a straw effigy known as Sanemori (regionally *shanemori-sama*) was paraded through rice-fields accompanied by men carrying blazing torches and making a great noise, to rid the crop of harmful insects. After this rite, known as *mushiokuri*, the straw effigy was burned or thrown in a river. Straw figures could also be used to cause pain and death by plunging nails or needles into them, and when two people of the same family died within a year, a straw doll was placed in a small coffin and buried, so that a third victim might be spared.

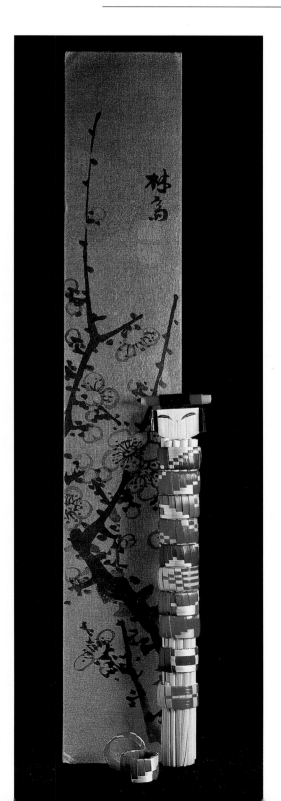

KOBE DOLL

KOBE NINGYO

WOOD

HYOGO PREFECTURE

Today, the Kobe doll, whether old or new, is a relatively rare and expensive find. First made between 1870 and 1920 at the busy port city of Kobe as a cheap sailor's souvenir, not many old examples have survived the vicissitudes of time. A few well-made new ones are sold today, but they miss that indefinable aura of age of the older examples. These amusing toys are manually activated by a knob at the side of the box containing the mechanism. They play musical instruments, ride in a cart, do gymnastics, eat melon, drink saké, play ghost... The mechanism was formerly entirely hand-crafted and the moon-faced personages made of polished or blackened wood, their eyes inlaid with scraps of bone or ivory. It is probable that these unusual moon-faced dolls were inspired by black sailors who disembarked at Kobe, when the port was opened in 1868.

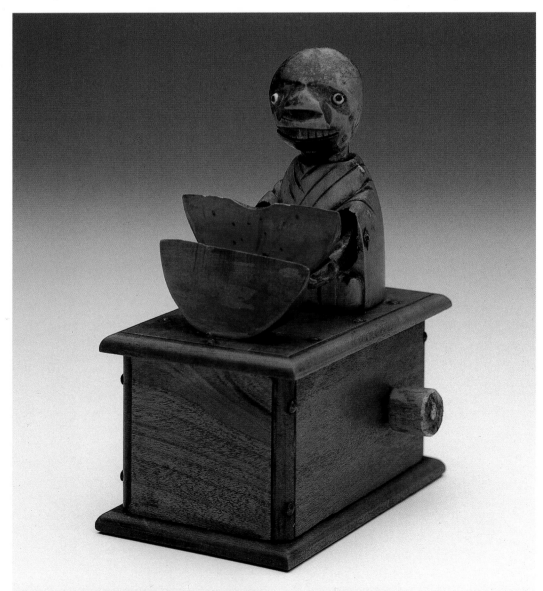

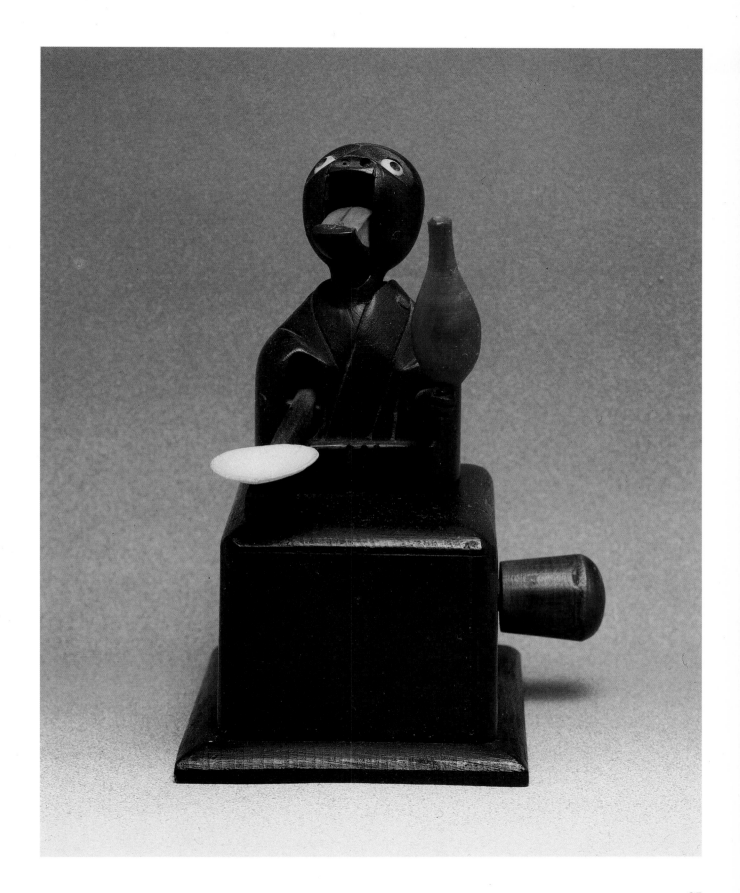

TIGER OF SHINNO

SHINNO TORA

PAPIER-MACHE

OSAKA PREFECTURE

This interesting charm is from Osaka's Shinno Shrine, dedicated primarily to the fortunes of pharmacists, which can only grow if they sell medicine. This seems to be a contradiction, for the tiger is sold at the annual festival in November with the assurance that the possessor of this toy will not become ill or be struck by an epidemic. Possibly the twig to which the tiger is tied has the deeper symbolism always associated with the tiger and bamboo: that the strong (pharmacists) need the weak (the sick) to survive. Shinno is the god of medicine, who discovered the curative properties of many plants. His rare depictions show him eating leaves. The tiger is sold suspended from a bamboo branch, and has the character for medicine stamped on its body. Like the majority of papier-mâché tigers, it has a swaying head and is painted bright yellow with black stripes and red touches. It has a long body, very short legs, and a remarkably thin tail curved over its back.

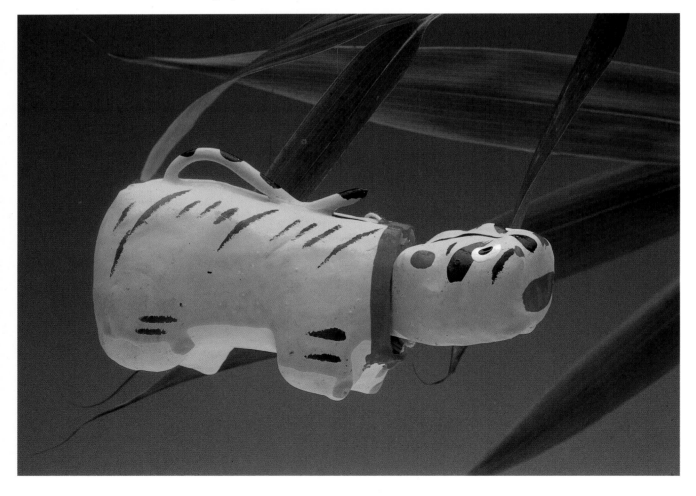

Twice a year, at the rice festivals of Osaka Sumiyoshi Shrine, the Sumiyoshi dance is performed in honor of the gods. The first dance petitions the gods for an abundant rice harvest, the second thanks them if the prayer has been answered. These festivities are a popular feature of the shrine, and many spectators take home a memento of the event. Known since the 16th century, the little toy is in fact a mobile, and the light, dangling rice-straw and paper figures, twisting and twirling in the breeze, are simple depictions of the dancers. Turning back the pages of (doll) history, it is remarkable that the paper silhouettes closely resemble the *hitogata* and *katashiro* of antiquity. These simple paper cutouts were sold at shrines, marked with the place of illness, and then burned. This toy, too, must be brought back to the shrine to be burned when a new one is bought. The circular roof is loosely woven and has a short red curtain, open on one side. There are four or more differently colored paper dancers. The Sentaikojin Shrine of Shinagawa, Tokyo, sells a similar toy.

DOG CHARMS

INU OMAMORI

CLAY

NARA PREFECTURE

This historical charm dates from the eighth century and comes from the oldest Buddhist convent for women in Japan, the Hokke-ji. Founded by the Empress Komyo (701-760), it was primarily devoted to the welfare of women, the poor, and the sick. At one time the empress held a great Buddhist ritual which lasted 17 days. The ashes remaining from the burned offerings were piously collected and mixed with clay from a nearby hill, to make small dogs as protective charms. The tradition continues to this day, but only a very small number is produced. The charms exist in three mini-sizes: two, three, and four centimeters. They are handmade of natural clay, sun-dried, painted white, and decorated with a string collar and a different motif for each. The largest has a chrysanthemum in memory of the imperial origin of the convent, the medium size has a pine branch for the Buddhist ritual of burning pine-wood, while the tiniest one has five red dots–health for the five parts of the body–and the ideograph for mountain, which furnishes the clay. The making of the charms is a religious rite, for the nuns recite sutras while working, and the completed dogs are blessed before an image of Kannon. Limited examples can be bought only at Hokke-ji, where an imperial princess or noblewoman has been abbess (*monzeki*) for the past 1,200 years. The little dogs protect from all evils and ensure a safe delivery.

A personal footnote to this story must be included, for I went specially to Nara to buy these charms, where a lady at the convent refused to sell me the last remaining large dog. Kannon must have disapproved of her uncooperative attitude, for on returning to Tokyo, I found the largest dog (an old one) in an antique shop, where a very kind gentleman gave it to me as a protective charm on my travels. Thank you, Nakajima-san!

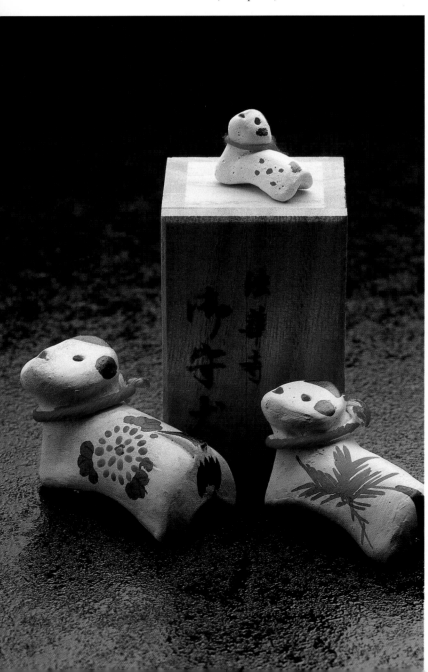

A prime example of the technique called *ittobori* or one-knife carving, the angular and multicolored Nara *ningyo* are among the most sophisticated types of folk dolls and it is difficult to imagine them as playthings. The noh theater originated at the famous Kasuga Shrine of Nara in the 14th century and was given its classical form by the father and son Kan'ami and Zeami. The sharp planes of the carving are well suited to the rendering of the stiff, sumptuous brocade of the noh costumes, so it is not sur-

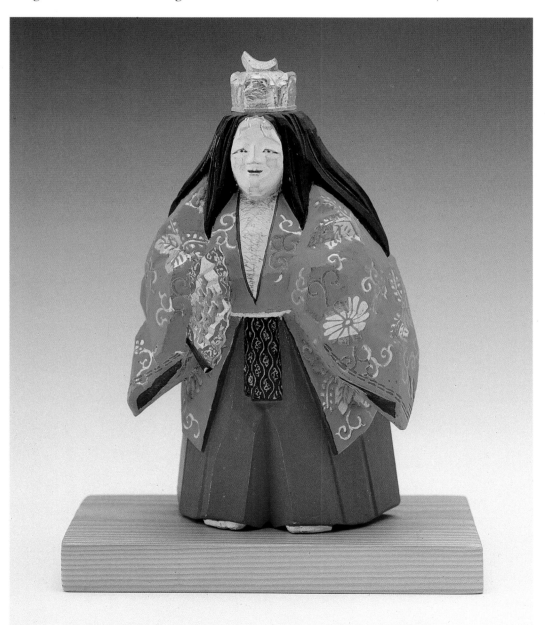

prising that most figures represent actors in famous roles wearing their splendid robes and wooden masks. In the Tekiho Nishizawa collection there is even a rare example of a Nara doll with a removable mask. Crudely carved "Nara" dolls had existed since the 12th century; before the advent of the noh theater they were used for divination during religious ceremonies at Harumi Shrine. However, since the 17th century the Nara doll in its present form has been attributed to a man named Okano Heiemon, and the tradition carried on by the Okano family for thirteen generations. Although colorful noh actors are considered the most typical Nara dolls, other well-known subjects exist, such as Jo and Uba, the happy old couple of Takasago, a popular wedding or anniversary gift. There are also small animals made of plain wood. Most Nara dolls are signed by their maker.

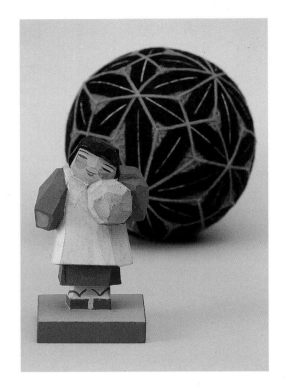

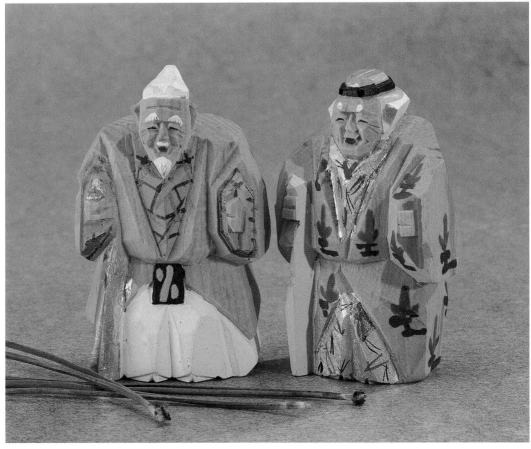

TAI-GURUMA

PAPIER-MACHE, WOOD

WAKAYAMA PREFECTURE

This fish cart is a traditional toy-emblem of Wakayama Prefecture. Together with rice, fish form the major part of the Japanese diet, so it is not surprising that the fish toy, made from various materials and in many shapes and sizes, is found from the north to the south of the Japanese islands. Of all the fish, the *tai* or red sea bream is the most prized as it is red, the auspicious color, which besides bringing luck, also drives away the evil spirits causing illness. It is served on all happy occasions, its name being a form of the word "*omedetai*" or congratulations. There is a Japanese saying "*kusatte mo tai*" meaning that even rotten it is still a *tai*... even damaged it is still valuable. Ebisu, the lucky god who presides over the riches of the sea, is always shown carrying this precious fish...

for those who honor Ebisu will always have enough to eat! The *tai*, whether in the form of a wheeled toy or a clay or papier-mâché figurine, is certainly one of the most popular symbols of all the good things wished for a child on its way through life.

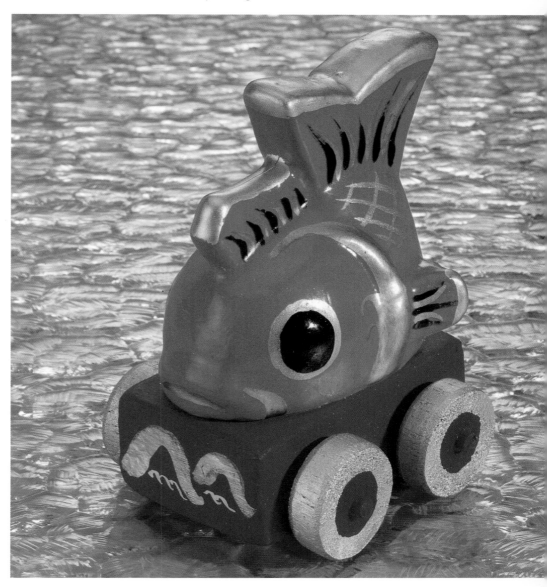

ROOF-TILE MONKEY

KAWARA-ZARU

CLAY

WAKAYAMA PREFECTURE

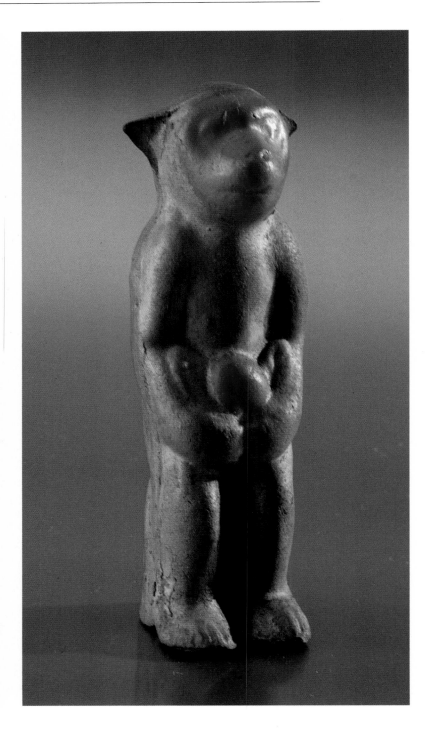

This mold-pressed figure is another example of a monkey toy with phallic connotations. It has a red face and a silvery-gray glaze. The name "tile monkey" comes from the material and coloring used, which is that of roof-tiles. It is also an indication that tile-makers made these monkeys as a sideline. A crude version of this amulet originated in the 12th century, when the tile-makers of a shrine that was completed on the day of the monkey made a monkey toy as a lucky charm. The monkey shown holds a red peach, a well-known oriental fertility symbol, which on the toy can also be interpreted as a phallus. It is a charm for the childless who wish to have fine, healthy children, preferably sons. As the eldest son carried on the family name and ancestral rites, he was an important link between gods and men, insuring the continuation of the line. It is not surprising that so many phallic images exist and are currently sold at shrines.

Chugoku District

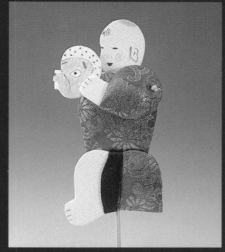

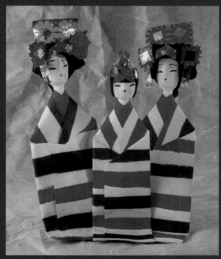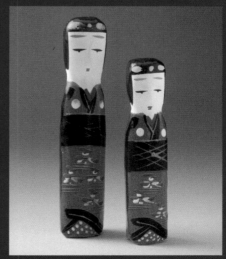

Prefectures of

HIROSHIMA TOTTORI

OKAYAMA YAMAGUCHI

SHIMANE

CASTING-AWAY DOLLS

NAGASHIBINA

PAPER, CLAY

TOTTORI PREFECTURE

A custom which is still very much alive in Tottori Prefecture is the setting afloat in a round woven-straw frame of a male-female pair of paper dolls. Their name comes from the verb *nagasu*: to let flow, to shed. On Girls' Day, the third of March, the dolls clad in a red paper kimono decorated with white plum blossom, are breathed on, held against the body, and set adrift in stream or sea to take with them the sins of the past year and all evils that may lie in wait for the coming year. Although the Tottori custom dates from the 15th century, the practice is lost in the mist of time, and is probably due to the assimilation of a Chinese purification rite into the Shinto rituals. The dolls have phallic and fertility connotations and are kept in the home for one year, when they are "cast away" and new ones bought. They exist in three versions: a man-woman pair in a wooden box, a man-woman pair in a round straw frame, and two rows forming ten pairs, held together by a horizontal bamboo clip. A standing wooden pair are souvenir dolls of Tottori inspired by the *tachibina*, "upright" or "straight" paper dolls of the Heian period. They are among the oldest doll types of Japan.

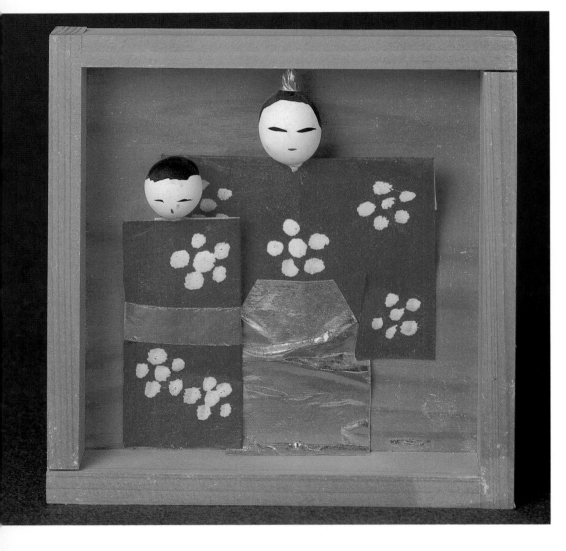

JUMPING HORSE
HARU KOMA

WOOD, BAMBOO, CARDBOARD

TOTTORI PREFECTURE

This colorful hobby-horse decorated with ribbons and bells is a miniature copy of an eighty-centimeter-long toy once made for the annual livestock fair of Oyama. It is still produced but now sold primarily at craft shops. The hobby-horse consisting of a horse's head, a stick, and a wheel, is a truly universal plaything, found all over the world since ancient times. There are a large num-ber of Edo-period woodblock prints and books showing horse toys, proving that children everywhere in Japan liked to play soldier and horse, even if they had to furnish the locomotive power themselves. The horse is symbolic of valor, virility, and endurance, and as such is included among the warriors and weapons for Boys' Day. As an *omiyage* of Tottori, it is perfect for small boys.

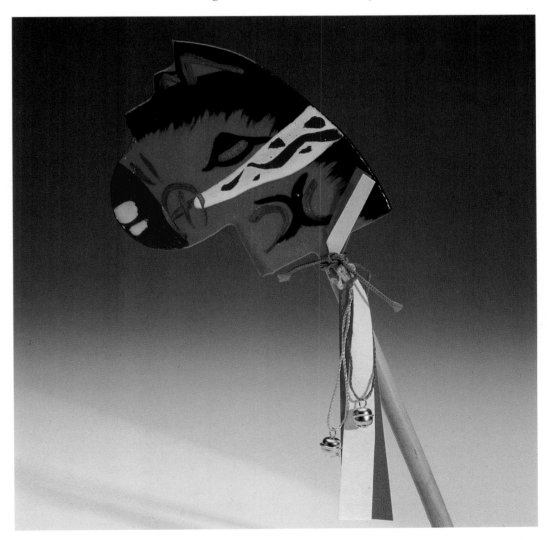

HAKOTA DOLL

HAKOTA NINGYO

PAPIER-MACHE

TOTTORI PREFECTURE

Hakota is the regional word used to describe a naive country girl, and tradition says that this doll was made to express the charm and modesty of the girls from Kurayoshi. The doll, soberly dressed in a red kimono and black obi, with a small triangle at the base showing her red and white tie-dyed under-robe, seems to be wrapped in her festival finery. The cylindrical shape resembles that of the *kokeshi*, a shape which is easily hand-formed or made over a mold. As many country girls were hired out by their parents to work in the cities, rustic dolls wearing red kimono, are also known as "servant dolls." (See also Honorable Hoko on page 118.)

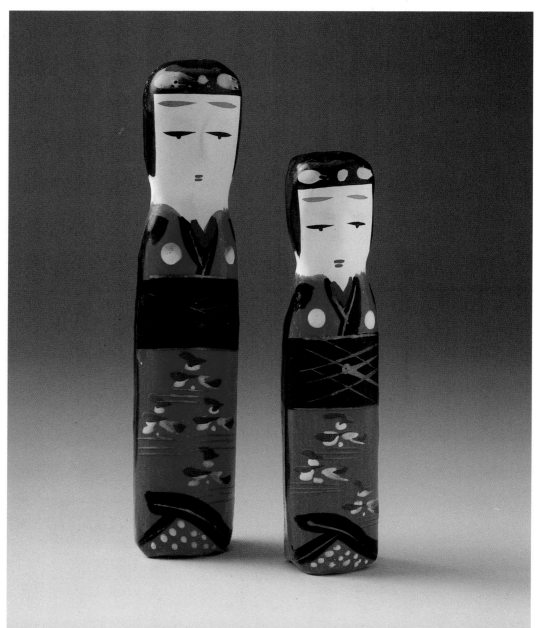

OSHI-E NINGYO

TEXTILE, PAPER, BAMBOO

TOTTORI PREFECTURE

A mobile toy known as a "mask wearer," made in the *oshi-e* or padded picture technique. Pieces of paper or cardboard are cut out, padded, glued, and covered with a variety of silks and brocades. They are then assembled to form a figure, the face careful- ly detailed with brush and ink. This toy, which is fixed to a bamboo stick, has mechanical interest, for it raises and lowers the comical *hyottoko* mask in front of its face, with the motions of a second stick attached to the mobile arm.

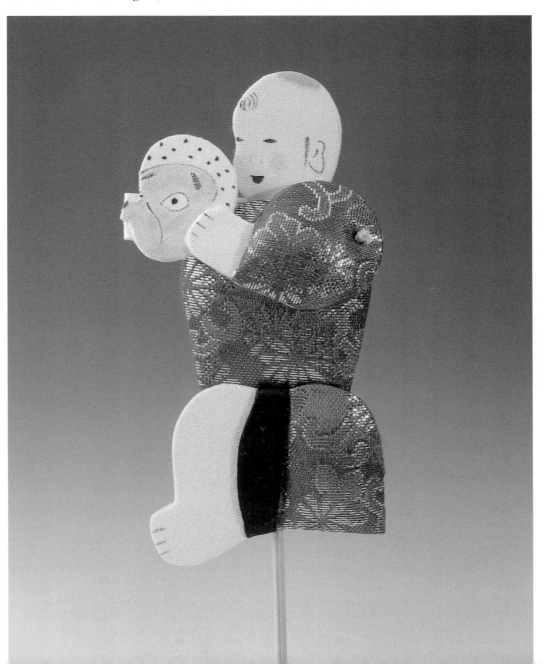

HINA DOLLS

HINA NINGYO

TEXTILE, PAPER

TOTTORI PREFECTURE

Tottori Prefecture takes pride in a great number of interesting folk toys, brightly and gaily painted and decorated. This was partly due to its location, facing the Sea of Japan, with bleak, wintry days giving it the name of "shady side" of the Chugoku district. Warm, luminous colors were used to enliven the children's playtime. The rustic *hina* were first made in the 18th century, when country people started imitating the sumptuous and costly *dairibina* or imperial dolls of the ruling class with inexpensive materials, so that their young daughters might also celebrate Girls' Day. The imperial couple are made of folded cloth and gold paper, the accessories limited to the scepter and hat of the male figure, and the fan, crown, and ribbons of the female figure. They are seated on a small rectangular black-lacquered base and have delicately painted features on a round cloth head. Although these little *hina* dolls are unpretentious and made with simple materials, they are not lacking in the quiet refinement which is a characteristic of the large *dairibina*.

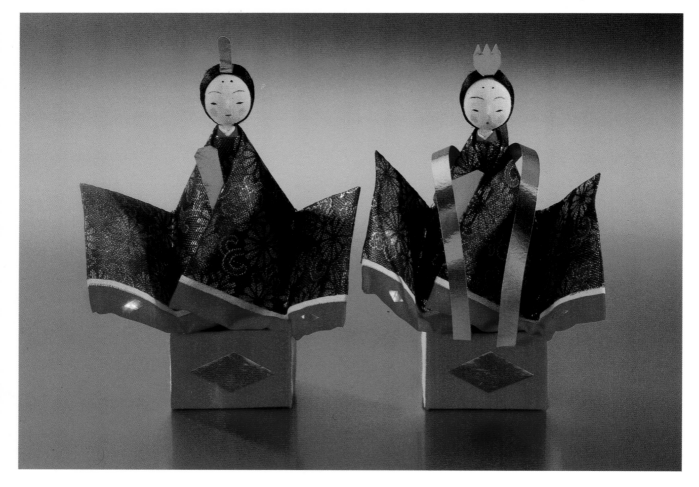

MOUSE
NEZUMI

PAPIER-MACHE

OKAYAMA PREFECTURE

In Japan, *nezumi* means both rat and mouse. Contrary to the western view of these rodents as pests to be exterminated, in the east they are esteemed as examples of intelligent industry. As they are found where food is plentiful, rats and mice are popular representatives of abundance and good fortune. The rat is the first animal of the oriental zodiac, and due to its symbolism, a very auspicious sign to be born under. Rats are the constant companions of Daikoku, the lucky god who brings out the riches of the land by striking the ground with his magic mallet. This wheeled papier-mâché rat is one of a series of the twelve zodiac animals, an original present for someone born in the year of the rat, a wish for wealth and prosperous business, symbolized by the gold *koban* coin it is carrying in its mouth. Pessimists do say, however, that rat and *koban* might be a warning to be watchful, and not let many small expenditures undermine and destroy a large fortune. A coin always has two sides!

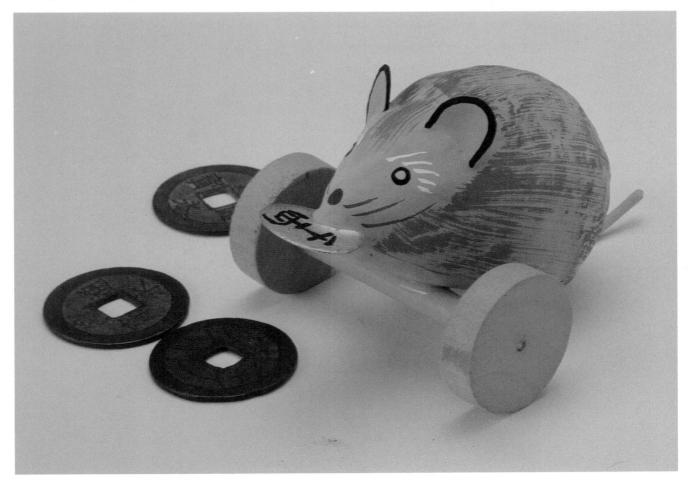

SUINKYO

SUINKYO

PAPIER-MACHE

OKAYAMA PREFECTURE

Other special toys of Okayama are the papier-mâché figures with bobbing heads known as *suinkyo*. They are miniatures of the masked men who lead the parade when the *mikoshi*, or portable shrines, of the Achi Shrine of Kurashiki City are carried around town on the third Saturday and Sunday of October. The figures have gray hair and their masks reproduce the features of old men and women; their blue and brown costumes are those worn at the festival. They wave fans with the word "Kurashiki" written on them. An interesting and touching story, historically correct, is told of these dolls. When the grandfather and grandmother of the Hino family, who had started this autumn festival, were in their nineties, they could no longer take part in the festivities, so the younger folk made masks of the aged couple and wore them, as if they were still accompanying the parade. The masked figures are called *jiji* and *baba*, familiar terms for old man and old woman; they are symbolic of a long and happy life. Salt is strewn along the route taken by the parade, a Shinto purifying ritual to keep away evil spirits. The old masks first made for this festival still exist and are conserved at the museum.

Miyajima, one of Japan's three most celebrated scenic sites, with its outer gate or *torii* set in the sea, is an island which was formerly considered as a god and worshipped as such. Women and agriculturalists were not allowed on it. The site was once known for its deer and monkeys living peacefully together. These animals are well suited to a "divine" island, for the deer are considered as messengers of the gods, the only animals that can find the *jui* or mushroom of longevity, while monkeys are fertility symbols and have guardian duties. The clay toys are now only nostalgic reminders of the friendly monkeys, for they have disappeared. The deer are handmade from unbaked, natural clay, each maker producing slightly different models; the males have thin, forked bamboo twigs as antlers. The coloring is sober: white spots on the body and white ears and tail, with black accentuating the backbone, eyes, and nose. The male deer has a red-faced monkey sitting on its back, in turn carrying a smaller monkey on its back, and holding a phallic peach. Charms made from the clay of "divine" Miyajima were thought to be particularly potent, as they were part of the god-island. The Shinto concept of divinity in nature is evident.

ELDER SISTER DOLLS

ANESAMA NINGYO

PAPER, CLAY

SHIMANE PREFECTURE

The traditional making of these dolls has been designated as an Intangible Cultural Asset, to help preserve the technique for the future. First a pastime of noblewomen, it became a cottage industry after the Meiji Restoration of 1868. Sold in sets of three with different and colorful hair ornaments in their paper coiffure, the dolls wear green-white-red striped kimono and have painted clay faces. It has been written in most books on Japanese dolls and folk toys (and the paper strip in the dolls' box still tells the story) that the writer Lafcadio Hearn (1850-1904) who lived in Matsue for some time and wrote so many sensitive stories about the Japan he loved, sent samples of these dolls to the (or a?) British Museum. With the help of Mr. Gregory Irvine of the British Museum, I researched this story, not only at the British Museum, but also at the Museum of Mankind, the Victoria and Albert Museum, and the Museum of Childhood at Bethnal Green. To my disappointment no trace or evidence exists of such a transaction... however I am still hoping... and the story does make good advertising!

PAPIER-MACHE TIGER

HARIKO NO TORA

PAPIER-MACHE

SHIMANE PREFECTURE

Imported from China by way of Korea, the tiger was never indigenous to Japan, and its great popularity as a toy is undoubtedly due to its fame as an exotic and colorful creature. It is bought to keep evil at bay (the tiger is guardian of the west), and to give victory in competition. Does it not have the ideograph for "king" written on its forehead? It seems yet another proof that immigrant Koreans, who brought so many innovations to Japan, also introduced the oriental zodiac and the animals unknown in Japan. The toy is made and sold near Izumo Taisha, a shrine built in the oldest style of architecture known in Japan, where the god Okuni-nushi-no-Mikoto is honored for having created agriculture, sericulture, and medicine. These three importations from Korea again indicate a China-via-Korea origin. Although the tiger has such an ancient ancestry, this toy was modeled after a famous wooden sculpture by an artist from Matsue, named Arakawa. In 1877, Takahashi Kumaichi acquired this tiger and made the original mold on whose model the present papier-mâché toys are still faithfully hand-formed. It is a fierce animal with a scowling face, bared teeth, big ears, and stiff whiskers, swaying its

mobile head in all directions and sporting a proud and practical, bolt-upright... removable tail. This tiger is the official representative of Shimane Prefecture's folk art; it was presented to the Emperor and Empress, and featured on the 1962 (year of the tiger) new year's stamp.

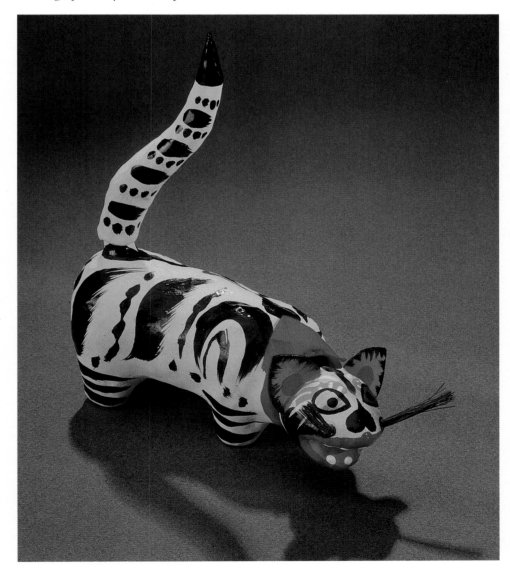

OUCHI DOLLS
OUCHI NINGYO

WOOD

YAMAGUCHI PREFECTURE

About 700 years ago, Ouchi Hiroyo married a beautiful lady from Heiankyo (Kyoto) and took her to his castle in Yamaguchi. But the lady, used to the refined atmosphere of the Kyoto court, pined away in the rustic countryside. For her pleasure, her husband filled a room with dolls in the Kyoto style. Brides were very young in those days, and Kyoto dolls very luxurious! The collection of dolls became famous, and the castle was known as *ningyo goten* or dolls' palace. Many doll-makers came to Yamaguchi, at first to sell

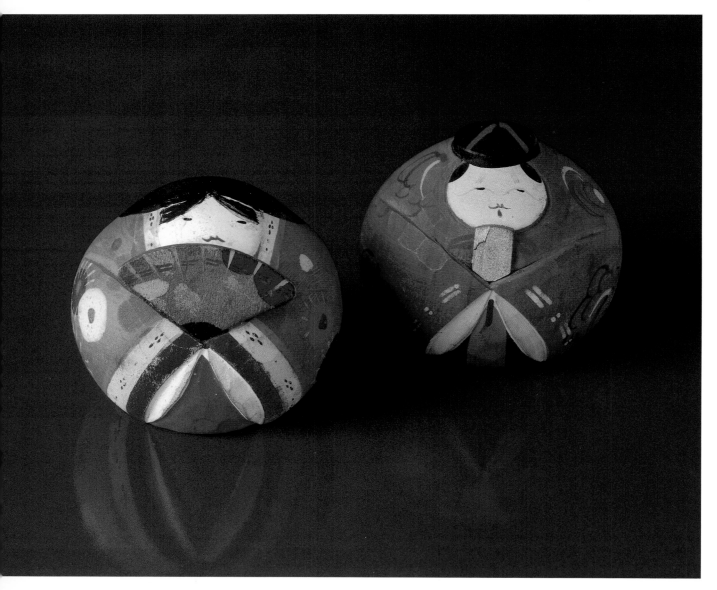

dolls to this private museum, then to establish their own commerce. Hiroyo's descendant, Yoshitaka (r.1528-1555) was defeated in battle and Yamaguchi twice ravaged by enemy troops. The Ouchi doll tradition died out but was revived some 70 years ago. The wooden dolls are simply made and soberly painted or entirely lacquered. They represent doll types from all over Japan, even *kokeshi*. Most Ouchi dolls can be identified by a particular decorative motif on their clothes, a stylized lozenge-shaped flower called *Ouchi-bishi*. The typical dolls are round and richly lacquered egg-shaped emperor and empress pairs, symbolizing a happy family, and harmony between husband and wife.

At Izumo Taisha in Shimane Prefecture, *ema* painted with a pair of Ouchi dolls are presented to the gods by those seeking good marriage partners. Izumo Taisha is famous as a matchmaking shrine and as gathering place for all the gods during the month of October. The rest of Japan is then without gods, and October is known as *Kannazuki* or "month of no gods." At Izumo it is then *Kamiarizuki* or "month of gods." One of the gods' most important discussions concerns the number of marriages for the coming year!

BLOWFISH WHISTLE

FUGU-BUE

CLAY

YAMAGUCHI PREFECTURE

This original whistle, in the shape of a *fugu* or blowfish, was formerly a present given by *sushi* restaurants and food shops to good customers. It comes from Shimonoseki and originated in the 1920's. It is a symbolic delicacy, for *fugu* was a highly esteemed and expensive dish. The *fugu* is a poisonous fish, improperly cleaned it can cause death, and is therefore also known as *teppo* or gunfish. Between 1886 and 1963, it was responsible for 10,745 known poisonings, of which 6,386 proved fatal. Formerly the blown-up and dried skin of a *fugu*, with a candle inside, functioned as a lantern. Real dried blowfish wearing a black lacquered hat are still sold at Fujisawa in Kanagawa Prefecture. They are often seen decorating *sushi* shops. Both whistle and lantern are now made in Fukuoka Prefecture, but sent to and only sold at their respective places of origin, Shimonoseki and Fujisawa. The whistle seems safer than the real thing!

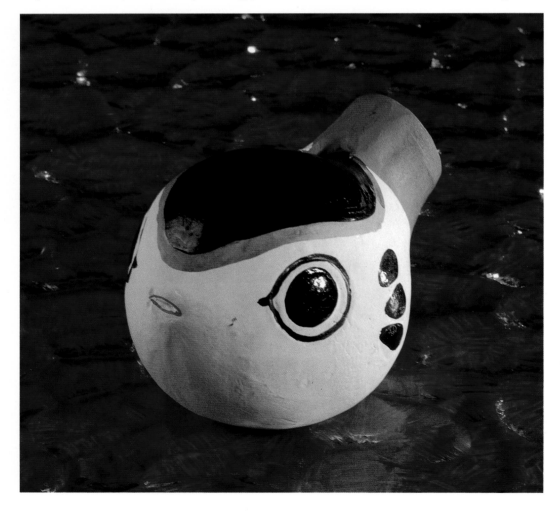

Shikoku District

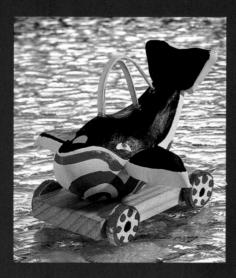

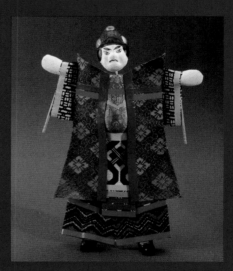

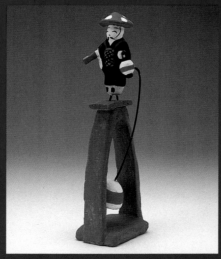

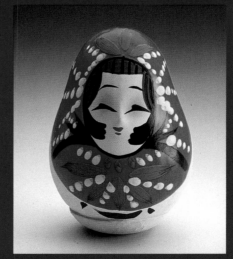

Prefectures of

EHIME TOKUSHIMA

KAGAWA

KOCHI

HONORABLE HOKO

HOKO-SAN

PAPIER-MACHE

KAGAWA PREFECTURE

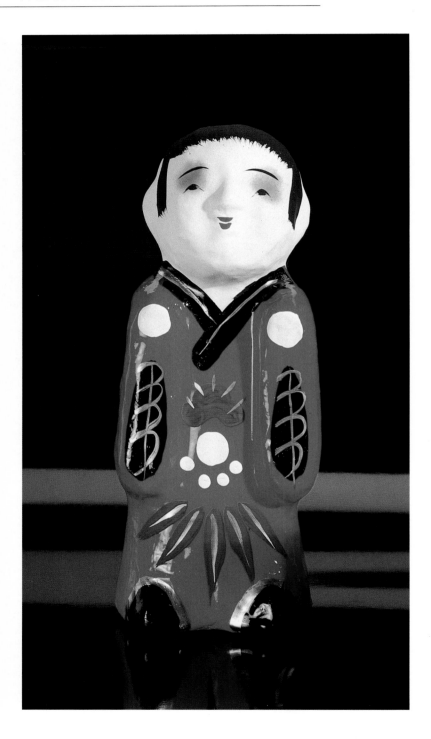

This brave little child named Omaki, was a maid to a young princess. When her mistress became ill with a contagious disease and no one dared come near her, Omaki devotedly took care of her until she recovered... but Omaki had by then also caught the disease. To protect the people she loved, she ran away and rowed a boat to a small island where she died. These dolls first made to honor Omaki's courage, are still handmade and purchased as charms against illness. The doll is put in bed with a sick child for one night and in the morning thrown into the sea, taking ills and pains with it. As she is a throwaway doll, Omaki is roughly formed and painted. She wears the red kimono of a maid (she is also called Hoko or servant doll) decorated with the pine-bamboo-plum motif, symbolic of a brighter future. The name Hoko-san could be derived from the ancient Hoko doll, a stitched talismanic doll made of white silk. Used since Heian times, it was placed near a newborn baby as a decoy to absorb all evil threatening the child's life.

A specialty of Takamatsu, this swaying doll on its two metal stilts can be precisely dated to Meiji 13 (1880) when the song "*Hera, Hera Hei Odori*" and the dance that accompanied it were popular hits of the day. There were at first two distinct models—a sweet-seller and the man-in-the-street with the title of the song written on his fan. An army trumpeter was included to form a trio when Japan won the 1894-1895 conflict with China and militarism was popular. The uniform tells us when the soldier toy was added, and that the song and dance were still in vogue. The toy is crudely modeled and painted, its appeal lying in the pendulum movement which gradually turns from quick to slow, like a clockwork running down. The popularity of these playthings ended when the song and dance craze waned, and for some time they were no longer produced. However, at present, small quantities are again being made for collectors. The figure represented is a sweet-seller, his wares carried in baskets slung from his shoulders. He holds a lantern in one hand, and a clapper to alert the children in the other. As peddlers would sing and dance to attract buyers, they were popular one-man shows and actively spread new song-and-dance fads around the country.

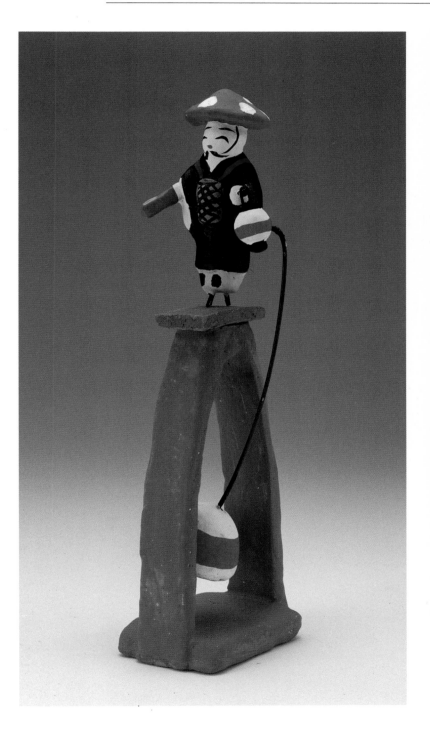

DOLL HEADS

KUBI NINGYO

CLAY, STRAW

TOKUSHIMA PREFECTURE

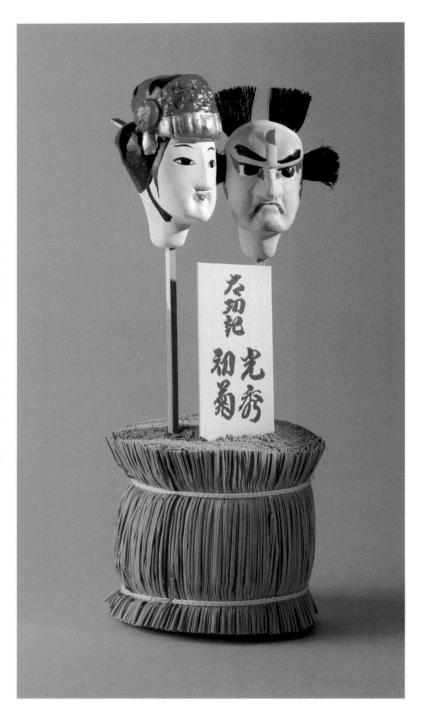

Not far from the coast of Tokushima and Hyogo prefectures, the island of Awaji is famous for puppetry and the carving of puppet heads for the bunraku theater, once one of the most popular entertainments in Japan. The craftsmen of Awaji and Tokushima brought the expressive heads to a high degree of excellence, and invented a sophisticated system activating mobile eyes, eyebrows, and mouths. The 16th-century founder of the carving art was a Shinto priest who had been banished from the mainland for performing for gain in rival temples. The two puppet heads represent the earlier and more rustic versions of bunraku heads, formerly used for the religious and popular festivals of the area. They are Hatsugiku and Mitsuhide from a still-popular play "Ehon Taikoki" by Chikamatsu Yanagi, a story of 16th-century warfare based on the feud between Oda Nobunaga (Harunaga in the play) and his general and murderer, Akechi Mitsuhide (Takechi in the play). The puppeteers of bygone days were not professionals, but farmers, shopkeepers, and fishermen, who put on naive shows featuring historical events and local happenings. At that time, there were no fixed theaters, so the miniature dramas were usually played in public buildings or outdoors, in the grounds of shrines and temples. Plays could last from 6 A.M. to 9 P.M., while the spectators sat, ate, and slept on the ground. The small puppet heads, now sold as souvenirs, keep alive the memory of this region's unique contribution to Japan's theatrical arts.

While most other *anesama*-type dolls are usually made without facial features, this doll has a large head with paper hair, an elaborate headdress and an exceptionally well-defined clay face, giving it a distinct personality. The type is about eighty years old. *Anesama*, as nearly all such paper dolls are named, is a courtesy title by which all younger children must call their eldest sister. The custom of leaving the face blank has two explanations. One is that it does not detract attention from the clothes and hairstyle. Another explanation is that everyone can imagine the features of a person dear to them. But the more probable theory is that the first fetishistic paper dolls (*hitogata, katashiro*) meant to be burned or thrown in water had no features. This deep-rooted custom is also found in modern civilizations, for the Mennonites and Amish people of the United States do not put facial features on their dolls, for religious reasons.

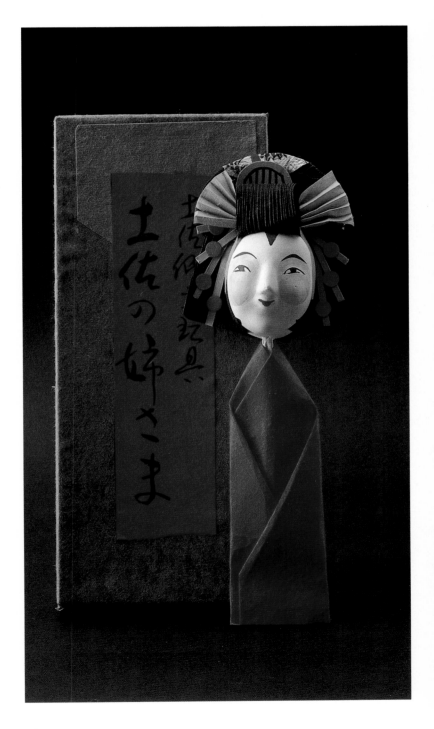

WHALE CART

KUJIRA-GURUMA

WOOD, PAPIER-MACHE

KOCHI PREFECTURE

From its establishment in the 17th century until the early 20th century, whaling was a thriving industry in Japan. The gigantic sea mammals were once a precious source of food and other necessities in a land isolated and poor in natural resources, a reason for whaling which is no longer valid today. In bygone days, no part of this great mammal was wasted, and it is probable that most of the house lanterns of the Japanese people were once alimented by the oil of whales. Rapeseed and whale oil mixed with vinegar made an efficient insecticide, and saved the rice crop in more than one case. As a modest accessory use, whalebone (*kuchihige*—whale's whiskers) served as springs in the curious tea-serving *karakuri* automated doll, as shown in the "Karakuri Zue" (Collection of Mechanical Designs) by Hosokawa Yorinao, printed in 1797. The miniature whale-cart of Kochi was carefully made for children by their father-whalers of the 17th century, but has now become a rather rough souvenir with immobile wheels, a pale reminder of past whaling days, when Asahina Saburo Yoshihide, a masterless samurai, devised swift boats and hunting methods. Taiji, a former whaling town in Wakayama Prefecture, has a museum devoted to whales and whaling.

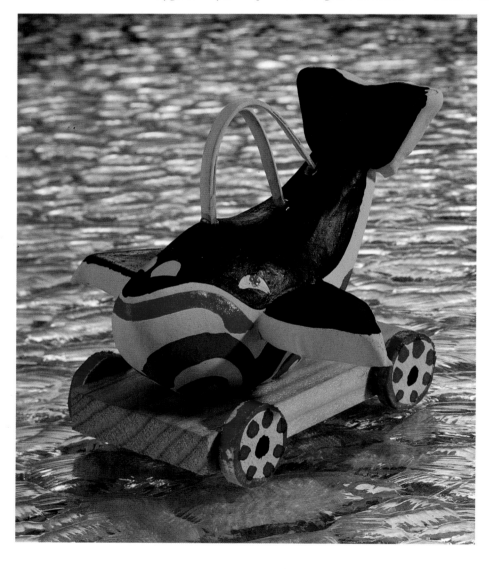

LADY DARUMA

ONNA DARUMA

PAPIER-MACHE

KOCHI PREFECTURE

This is yet another female version of the versatile and venerable monk who always rises, no matter how often he falls. Perhaps the reason why ladies of the night are euphemistically called "*daruma* geisha" in Japan. It seems that this toy was modeled after a celebrated beauty of the Meiji period who cut her hair in western fashion. The lady is creatively decorated with *shibori* tie-and-dye motifs often found on expensive kimono. *Daruma* is sometimes pictured walking happily with a lovely courtesan with whom he has exchanged clothes, meaning that enlightenment is accessible to saint and sinner alike...or that the clothes do not necessarily make the man!

THE HAIRPIN MONK

BOSAN KANZASHI

PAPIER-MACHE

KOCHI PREFECTURE

First made during the Meiji era, this toy is based on the true story of a pious Buddhist monk, Junshin, who fell in love with a beautiful woman named Ouma. In the center of Kochi City, in a shop near the small Harimaya Bridge, Junshin went to buy a *kanzashi* or hairpin for the lady of his dreams... and this present marked the beginning of their idyll. People gossiped, as people will, but Ouma returned Junshin's tender sentiments, which proved stronger than his vows of celibacy. Their great passion became the theme of a well-known folk ballad called "*Yosakoi Bushi*." The toy shows the couple under one umbrella, known in Japan as "*ai-ai gasa*" or "love umbrella," a depiction symbolic of a love affair. It is a secret meeting at night, for the stooping Junshin carries a lantern and hides his face behind a scarf, while Ouma puts her arm around her timid lover and proudly holds her head high. A paper *obi* or sash is glued to Ouma's side... that it is untied is an unmistakable erotic symbol. This colorful little toy is remarkable for its double-figure technique, an innovation which came into vogue at the end of the Edo period. Junshin's head is mounted on a wire and sways from side to side, so that he seems to be looking around, afraid to be seen.

The *ushi oni* or ox devil is a caricature of an ox with a long neck, sharp teeth, black and white striped horns, and a sword-like tail. Since the 18th century, this seven-meter-high red monster has been carried around at the local festival of the Warei Shrine of Uwajima, which is celebrated on July 23 and 24. For the purification of the town, it is paraded along the streets by a group of young men, who receive money from the inhabitants living along the streets where it is taken. People who go to this festival are sure to buy a miniature model of the giant ox devil as a souvenir and for personal purification. There are brown wooden heads and models of the entire animal carved by the one-knife, or *ittobori*, technique, and red papier-mâché toys with a cloth neck through which the head can easily be moved.

HIME DARUMA

PAPIER-MACHE

EHIME PREFECTURE

The tumbling *daruma* is one of the most popular *engi* or luck-bringing toys of Japan. The dolls come in all shapes and sizes, with and without eyes, clean-shaven and with whiskers, plain-colored and decorated, male and female. The Hime or Princess *daruma* from Matsuyama is one of the prettiest female *daruma* figures of the large family. It seems that when Empress Jingu became pregnant, the child she carried, the future

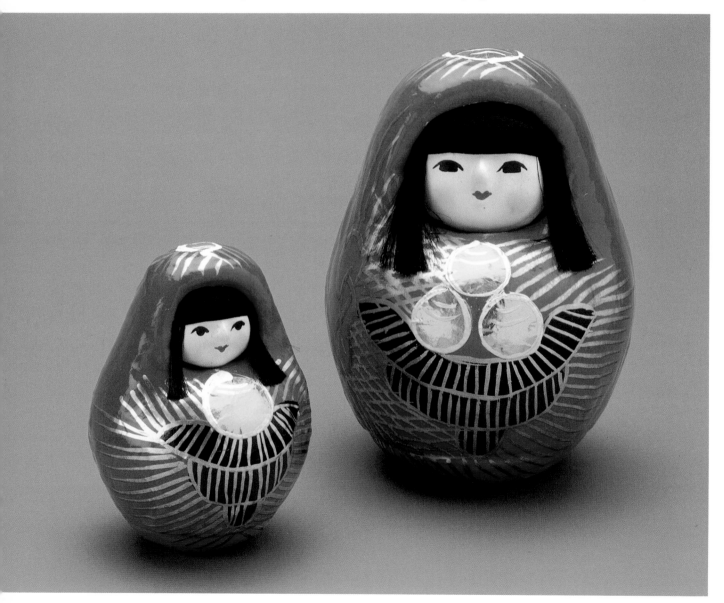

Emperor Ojin, was named "the emperor in the womb." The gods had promised him the "three Han"—the three Korean kingdoms that Empress Jingu was to conquer: Paekche, Koryo, and Silla. The three *tama* or jewels with which the doll is decorated symbolize the three conquered kingdoms and the tribute that the empress brought back from the "land of treasures" for her unborn son. Later, the Emperor Ojin had a beloved wife named (Y)ehime, and perhaps the Hime *daruma*, produced in Ehime Prefecture in 1861 was based on this play of words and forms a mother-child-wife trinity, as there are sizes decorated with respectively one, two, and

three *tama*, symbolizing three generations. The first dolls were made of wood, quickly followed by papier-mâché examples. The little princess is painted a protective red with gold-paper *tama* or jewels in a black vessel outlined on her clothes and has one *tama* on her head. Her face is delicately modeled and painted, and she has stiff black hair. She is invoked for prosperity and a safe childbirth, and presented to parents as a congratulatory gift. Today, *daruma* dolls wrapped in rich silks and brocades are sold throughout Japan as souvenirs. They are also called Hime *daruma*, but only the red princess from Ehime is the true aristocrat.

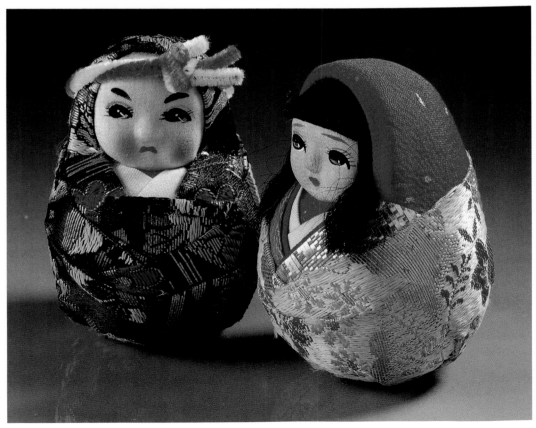

WARRIOR PUPPET

MUSHA NINGYO

CLAY, PAPER, TEXTILE

EHIME PREFECTURE

As the island of Awaji was virtually the birthplace of Japanese puppetry, many miniature puppet heads are sold along the coastal regions of the prefectures around Awaji. This unusual puppet is wearing a full-dress costume of battle armor, and its head and arms are activated by three sticks. It can be bought at Matsuyama, together with seven interchangeable heads on a stand, including heroes, demons, and animals. The dolls, which had been popular in the Meiji and Taisho periods, disappeared for a time, but are again being made today, true to the original model. They are sold by shops and shrines as amulets for the health and safety of children...as well as for their amusement and instruction.

Kyushu District and Okinawa

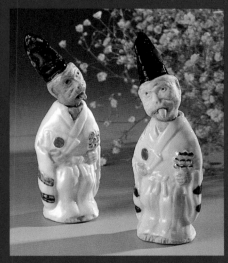
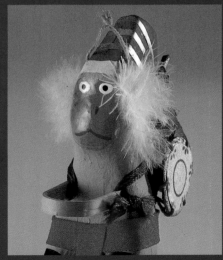

Prefectures of

FUKUOKA	**MIYAZAKI**	**OKINAWA**
KAGOSHIMA	**NAGASAKI**	**SAGA**
KUMAMOTO	**OITA**	

BULLFINCH OF DAZAIFU

DAZAIFU NO USO

WOOD

FUKUOKA PREFECTURE

On the seventh day of January, people from near and far flock to the Tenmangu Shrine of Dazaifu, where there is an *usokae* or bullfinch exchange... meaning that a dona-tion is exchanged for an amulet. The previous year's birds are returned to the sanctuary to be burned, and new ones bought to replace them. Exchange is a prettier word

than sale, but also relates to an old custom of buying bullfinches outside the shrine grounds, and at nightfall, exchanging them with strangers in the hope of receiving one of the twelve golden birds sent out by the shrine. The ceremony is an ancient one, presumably dating back to the end of the tenth century (Kanwa 985-987). The birds are carved from a single cylindrical piece of wood, and have a half-circle of three or four rows of deftly curled wing and tail feathers fanning out around them. A well-balanced contrast is formed by the body and head with their simply cut planes. A red breast, black eyes and feet, blue and red touches on the tail, and a gold-foil patch on the flat head are effective accents on the natural wood. The bird is marked at the back with a burned-in seal of the shrine. Dazaifu is the principal shrine of many spread throughout Japan that are dedicated to Sugawara Michizane (845-903). The bullfinch is associated with him because the word for bullfinch (*uso*) is a homonym for the word "lie." Michizane, an upright and honest statesman, was exiled from the Kyoto court through the calumnies (*uso*) of his rivals. When he died, storms, floods, and earthquakes struck the capital, and ended only when he was rehabilitated and shrines built in his honor. Best known as Tenjin, he was deified as god of learning and calligraphy, protector from lightning and other natural disasters. He is much petitioned by students at examination time. The reason for buying a bullfinch at the beginning of a new year is to make a lie of the bad luck which is perhaps lying ahead, and to make the ill-fortune of the past year appear as insubstantial as... an *uso* flying away. Michizane is usually represented with a large plum-flower crest decorating his clothes, for as he left for exile, he composed a poem for his favorite tree:

Send your perfume on the wind, my tree, and though the master is not here to see, do not forget to blossom in the spring.

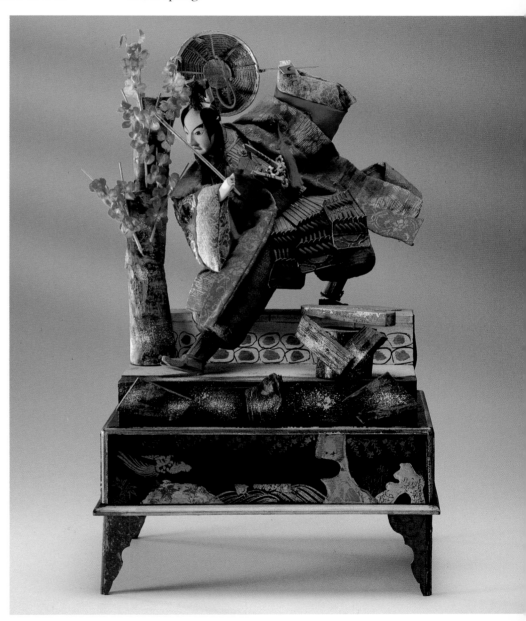

NOGOMI MASK

NOGOMI MEN

CLAY, RAFFIA

SAGA PREFECTURE

Kyushu is known for many kinds of clay and porcelain figurines, and this is a famous example. Made in Kashima, an area formerly known as Nogomi, it is a grimacing devil mask colored red, black, and gold with tufts of raffia hair. Life-size masks are worn by participants in *furyu* or festival dance rituals, praying for a good harvest. Dancers sing to the accompaniment of flutes, drums, and bells, repeating "let rain fall, keep insects away." It is noteworthy that the more menac-ing the expression of the mask, the more effective it is thought to be in keeping evil away. The oldest example in the Nogomi tra-dition is probably the clay horse with a raffia tail, carrying on its back a flaming pearl, sym-bolic of spiritual and material riches. The *jun-ishi* or twelve zodiac animals also exist as miniatures or bells, all colorfully decorated with black, blue, red, and yellow, on a white background. All these charms form a colorful clay world guaranteed to keep the buyer safe.

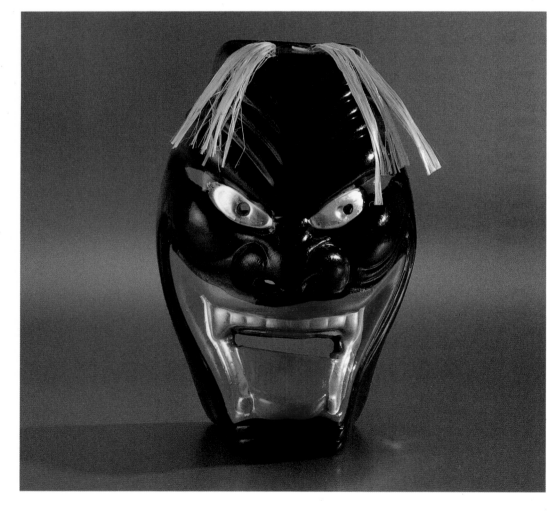

The Koga doll of Nagasaki, together with the Fushimi doll of Kyoto and the Tsutsumi doll of Sendai, comprise the three major clay doll traditions of Japan. The origin of Koga dolls goes back to the Bunroku period (1592-1596) when a doll-maker from Edo settled in the city and started producing animal themes. Human forms followed later, and as Nagasaki was the only city where the Dutch and Chinese were allowed after the anti-Christian edict of Tokugawa Ieyasu, foreigners were popular subject matter for the souvenir trade. There are still three classical models of these exotic strangers being made: a Chinese known as "Acha-san" holding a fighting rooster or *shamo* (the Chinese were addicted to gambling and cockfights); a Dutch captain in dress uniform holding a gun, which was in fact a Portuguese import; and the ill-fated Titia Blomhoff with her small child. This poor lady accompanied her husband to Nagasaki, but women being strictly forbidden, she was sent back and died on the return journey. The toy could also represent Mimi de Villeneuve, who came to Dejima in 1829 with her baby. She hoped to stay with her husband, but was sent back to Djakarta after two months. The figurines are dressed in sober black with red, yellow, blue, and gold accents. They are unique representatives of the Japanese clay doll tradition, which has always stayed true to the first models in form and spirit.

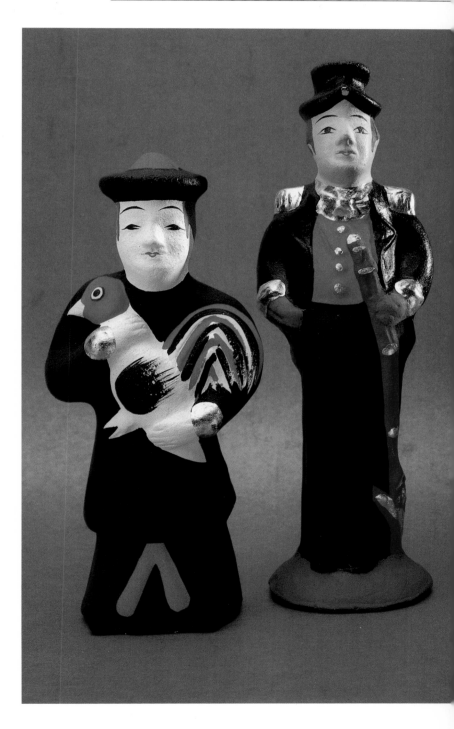

TONGUE SHOWING DOLL

SHITA DASHI NINGYO

PORCELAIN

NAGASAKI PREFECTURE

After one of Toyotomi Hideyoshi's two unsuccessful invasions of Korea (1592 and 1597), the Hirado daimyo Matsuura, who was a connoisseur of porcelain, brought back a skilled potter from Korea. He was given a Japanese name, Imamura, and it is to this man that we owe the first typical Hirado ware, known as *Hirado-yaki,* one of the finest quality porcelain wares in Japan. The daimyo gave generous financial support to Imamura, and later to his son and grandson, to improve and expand porcelain making. After much research, in 1650, the three generations made the first *karako-yaki* in imitation of Chinese blue and white porcelain. This delicate technique, showing playing children, is now designated as an Intangible Cultural Asset and continued by one craftsman, Hirado Gasho. One day at a court feast, the three men danced a comical monkey dance which was much praised by the amused emperor. The porcelain monkey, which has a separate movable head with a mobile tongue— quite a feat in porcelain making—was made in memory of this event. There is also a small *netsuke* version, and both figurines have always been popular souvenirs of Hirado.

A curious blend of a *kokeshi* doll with limbs, the Benta doll, carved with the one-knife, or *ittobori* technique, is made at the hot-spring resort of Hinagu. Some sources say the doll is of Korean origin and that the first maker, Benta, modeled it in clay after the likeness of the woman he loved, named Okinjo, (which means metal or gold woman). However, the doll has the typical bib-like apron decorated with red flowers and green leaves worn by little boys and often seen on boy Gosho dolls, so the mystery of identity still remains unsolved. Head and torso are roughly cut from a single cylindrical piece of paulownia-wood, hence the name *ichi-boku-bori* or single-piece wood carving. The flat, flimsy limbs are attached by strips of red cotton cloth nailed to the body, and seem to be an early attempt to make dolls with movable arms and legs. There are old variations of this doll with a rounded head, nicely modeled features, and sculptured limbs with well-defined hands and feet. The body of these older examples is made of a sawdust or wheat germ compound, and they are known as *nerimono* or "kneaded" things. They are curious little figures which reflect favorably the rusticity of country toys.

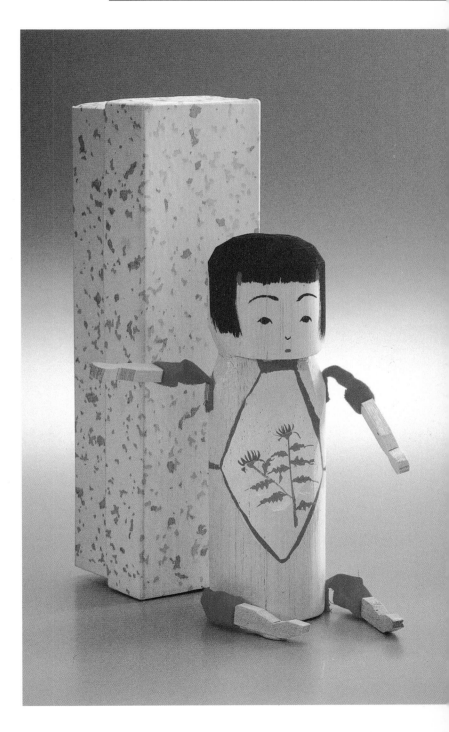

BOARD SUMO

ITA SUMO

WOOD (Paulownia imperialis)

KUMAMOTO PREFECTURE

Mentioned in ancient Japanese chronicles as dating back 2,000 years, *sumo* has been known since the 8th century as the national sport of Japan. In AD 858, the throne of Japan was wrestled for and given to the Emperor Seiwa because his champion had won the match. *Sumo* was formerly practiced in the open, in shrine and temple grounds on days of religious feasts. The admission fee served to raise funds for rebuilding and charities. To call attention to the tournaments, a wooden tower was raised, from which a drum was played and where the names of the participants were displayed. This tower was also a sign of official permission for the fights. Instead of intense muscular training, the favorite pastime of these immense wrestlers is eating and drinking, as weight is an important factor in the prescribed holds of this sport. The mobile toy, made of lightweight *kiri* or paulownia wood is cut from thin planks or boards, giving it the name "board" or "plank" *sumo*; the dangling legs are attached with cord, but the two arms are common property. The faces and typical *sumo* coiffure are painted with black *sumi* ink, one wears a red cord, the other a green one. Made in Higo in the Edo period, when travelling *sumo* matches caused a great sensation in the isolated areas of Japan, these toys are also illustrated in the Edo-period book of toys "Edo Nishiki" printed in 1773. The articulated toy can be moved with a stick inserted in the arms—and the *sumo* holds and throws can all be simulated. For statisticians: there are 48 rules observed in this sport, and three basic techniques consisting of hand-pushing, body pushing, and thrusting; there are 12 throws, 12 twists, 12 backward pushes, and 12 lifts, combining into 48 possibilities for throwing your opponent to the ground or out of the ring!

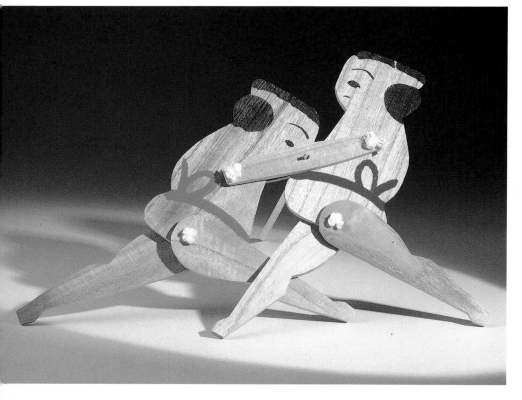

For statisticians and hobbyists: the *sumo* tower is 18 centimeters high; it is made of more than one hundred thin bamboo sticks tied together with a hundred and twenty knots the signboard has three hundred and thirty-eight characters on a two-by-two centimeter area!

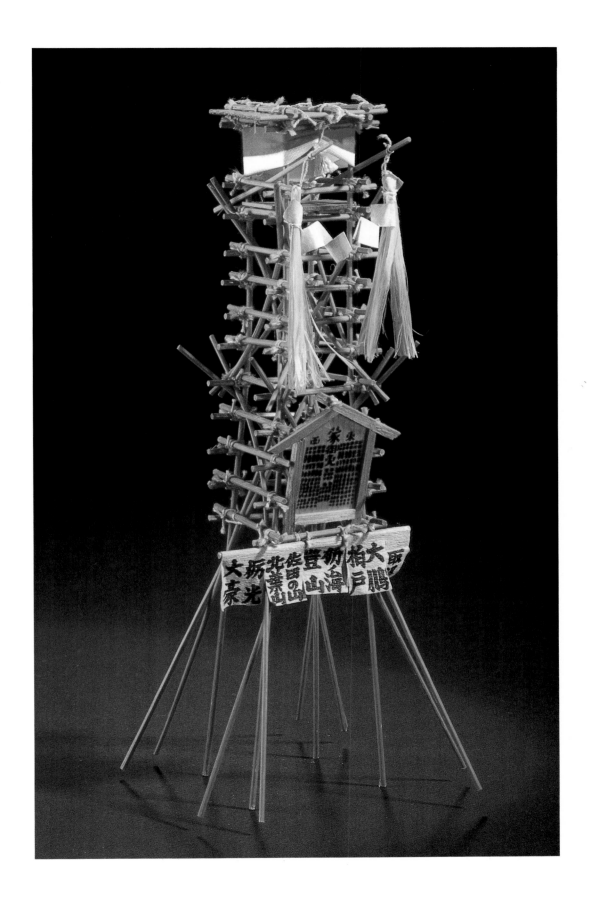

KINTA THE GOBLIN

OBAKE NO KINTA

WOOD, PAPIER-MACHE

KUMAMOTO PREFECTURE

Perhaps the best-known of Kumamoto's folk toys, Kinta has amused many generations of children and collectors. Based on a real personage, Kinta was a foot soldier in the service of Kato Kiyomasa, the notorious Christian hater and builder of Kumamoto Castle. Kinta was addicted to drink–hence the red face–and to playing jokes on people. The practice of playing ghost probably belonged to his repertory, for he is also known as *mekuri dashi ningyo* or bulging-eyed doll, and *obake*, ghost, goblin, or monster doll. A string activates the inner mechanism and Kinta rolls his black and white eyes while putting out his tongue. He wears a military black-lacquered hat over stiff black hair, and as befits a malicious goblin, he is firmly fixed to his wooden base! Kinta is a delightful and successful toy.

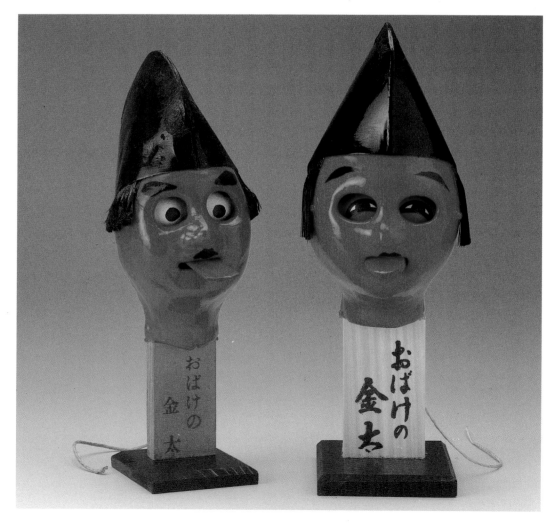

An interesting folk toy from Tamahigashi, this hand-formed phallic monkey is made from natural clay. It is lightly baked and unglazed, sparsely flecked with gold dust. One of the oldest toy amulets in Japan, it dates from the eighth century, and originated in a mountain region named Kiba or Konoha. The potters of a village located in this area had made ceremonial vessels to appease the gods of Kasuga Shrine, and, so legend tells us, the leftover clay suddenly turned into a live monkey. Since then it was believed that monkey figures made from the clay of Ameyama (a local mountain) would bring luck and fertility. There are various male and female versions of these monkeys, the most complicated ride a horse and have red, white, and blue spots. As similar fertility fetishes are found on certain South Sea islands, it is possible that these ancient monkey images were inspired by those imported by immigrants in the remote past.

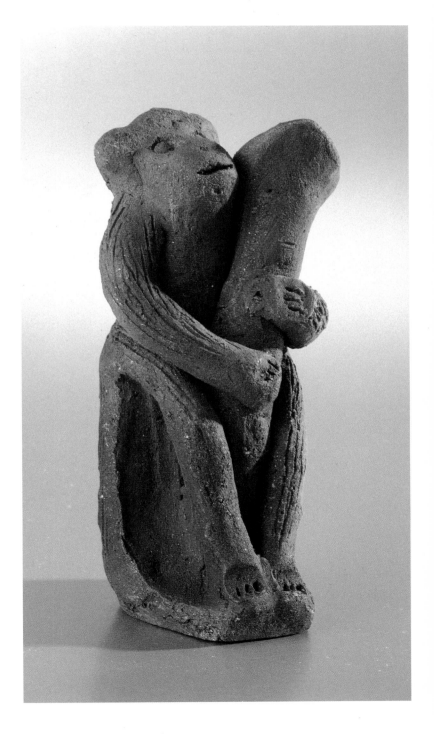

KIDEKO

KIDEKO

WOOD

OITA PREFECTURE

The Kideko of Beppu in Oita Prefecture has much the same functions as the Shogun markers of Saitama Prefecture: protection from evil and natural disasters. Their resemblance is remarkable and the Korean origin of both amulets is confirmed by the story that the Kideko was inspired by a Japanese warrior's description of exotic and powerful charms he had seen in Korea during Hideyoshi's invasion of that country at the end of the 16th century.

As the Kideko averts danger from the sky, the wooden *naruko* or bird frightener is aptly hung with a row of miniature, grimacing Kideko, which will clack in the wind and keep birds away from crops.

Another *engi* or luck-bringing toy is the lady *daruma* from Oita. To start the new year in the best possible way, these dolls are thrown into the houses of friends in the early morning of new year's day as a symbol of unexpected luck. Like the toy returning to an upright position, it also implies that they may immediately recover from eventual mishaps during the coming year. The doll is decorated with the auspicious pine-bamboo-plum motif on a red background, and is remarkable for its simple yet refined features, delicately painted on a long face which takes up more than half of the total height. She is a charming representative of Oita.

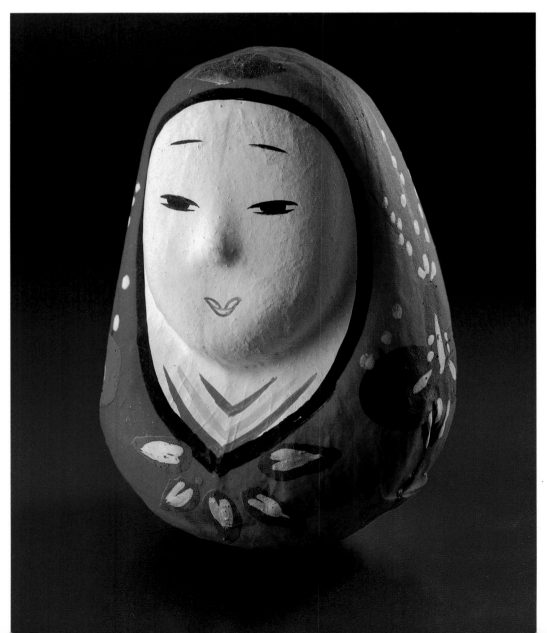

CLIMBING MONKEY

NOBORI-ZARU

PAPIER-MACHE, BAMBOO

MIYAZAKI PREFECTURE

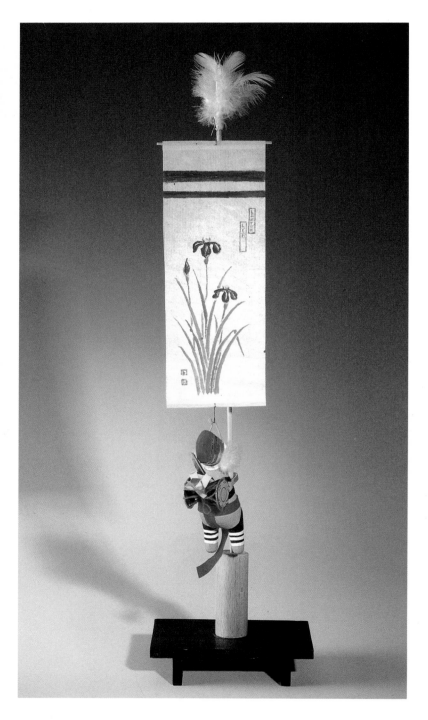

The woodblock-printed book of the Edo period, "Edo Nishiki," dated Anei 2 (1773), shows a simplified version of this toy monkey, wearing a straw hat and coat. It is usually given to parents of a newborn baby boy as a protective amulet against illness, and also symbolizes the wish that the child may climb to a high position in life. The banner, which is painted with an iris, the flower emblem of Boys' Day, is attached to the monkey and acts like a sail in the wind—as it tightens or loosens, the monkey climbs or descends the pole. Trained monkeys were often dressed in the costume of *Sambaso* dancers, whose dance was meant to appease the gods and bring good luck. This gray monkey wears the blue and gold hat of a *Sambaso* dancer and a red loincloth; it carries a small drum and a Shinto *gohei* (a cut-paper offering to the gods) on its back. It has a very red face and white feathers for hair.

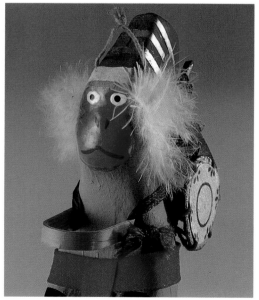

MANJU-KUI

CLAY

MIYAZAKI PREFECTURE

Created some three hundred years ago, the clay dolls of Sadohara owe much to the Fushimi doll tradition of Kyoto, and many similar models are found in both repertories... perhaps a proof of "industrial spying" of that time. The "bun eater" is a popular subject of the two manufactures, mirroring the story of a small boy who was given a bun to tell whether he loves his father or mother best. The clever child breaks the bean-paste bun *(manju)* in half, and counters with the question "which half is more delicious?" After an initial period of simplification and crude finishing, the dolls are at present well modeled and carefully painted in bright but not gaudy colors. They have now become more like artistic statuettes, compared with the lively and spontaneous folk artifacts of earlier days.

QUAIL CART
UZURA-GURUMA

WOOD

MIYAZAKI PREFECTURE

It is interesting to note that many simple wheeled toys come from Kyushu, and that the wheel was in use in Japan by the sixth century. It is perhaps not too far-fetched to attribute this fact to the influx of Korean immigrants who came to Kyushu after the Japanese lost Mimana, their stronghold in Korea, in 562. The Koreans brought many innovations to Japan, among others the Chinese calendar and ideographic script. It is probable that the wheel was included in their technological heritage from the Chinese, who had used it since the Shang dynasty of the 13th century BC. The first two-wheeled quail toy is attributed to a Korean, who made it on reaching his 100th birthday, as a memento for his descendants. Sold at the temples of Hokkedake and Hisamine, the quails have become charms for helping women in childbirth, and as they are always sold as a male-female pair, a hope for healthy children of both sexes. They are also charms for a happy old age.

PAPIER-MACHE

KAGOSHIMA PREFECTURE

Kagoshima's folk toys are of a truly rough and uninhibited kind. The papier-mâché *kappa* toy has movable arms, raising a slice of watermelon to its mouth when a string is pulled. It is a strikingly colored and amusing little monster that undoubtedly has great appeal for children. Like E.T. of film fame, it is so comically ugly that it becomes lovable. The mythical *kappa* is a purely Japanese invention. It is a mischievous water sprite which tries to pull unwary washerwomen and drinking cattle into the water. It has a predilection for cucumbers and watermelons, which it steals at night (there are charms against melon thieves!). The *kappa* has a hollow on top of its head containing a magic liquid giving supernatural strength. When meeting a *kappa*, one must greet it very politely, bowing low. The *kappa*, being blessed with the legendary Japanese politeness, will return the greeting, and so lose the liquid and its magic power. You have been warned!

CHILD AND FISH

KODOMO TO SAKANA

PAPIER-MACHE

OKINAWA PREFECTURE

Formerly known as the Ryukyu or Luchu islands, since 1972 Okinawa (named after the largest island in the group) has become Japan's 47th and most southerly prefecture. It has a semi-tropical climate and its population is thought to be a mixture of Japanese, Polynesians, and southeast Asians. Since ancient times it has been a strategic point for sailors, immigrants, and invaders from many different nations: China, Korea, Taiwan, Indonesia, Japan, and in the Pacific War, the United States, used it as base and stepping stone. The Ryukyus were always cross-cultural islands: lacquer and ceramics came from China, *kasuri* weaving with pre-dyed thread from Indonesia, and *bingata*, stencil-dyed cloth, from India and Japan. An important export from the Ryukyu islands to Japan was the three-stringed *shamisen*, which became one of the most popular musical instruments of the Edo period. The folk arts are true and unpretentious, and were highly praised by Yanagi Soetsu in his book "The Unknown Craftsman." Most folk toys are made of papier-mâché and represent happy children, rowing boats, and colorful fish with mobile fins, reflecting a carefree life and the sunny island climate.

FOLK TOYS AROUND JAPAN

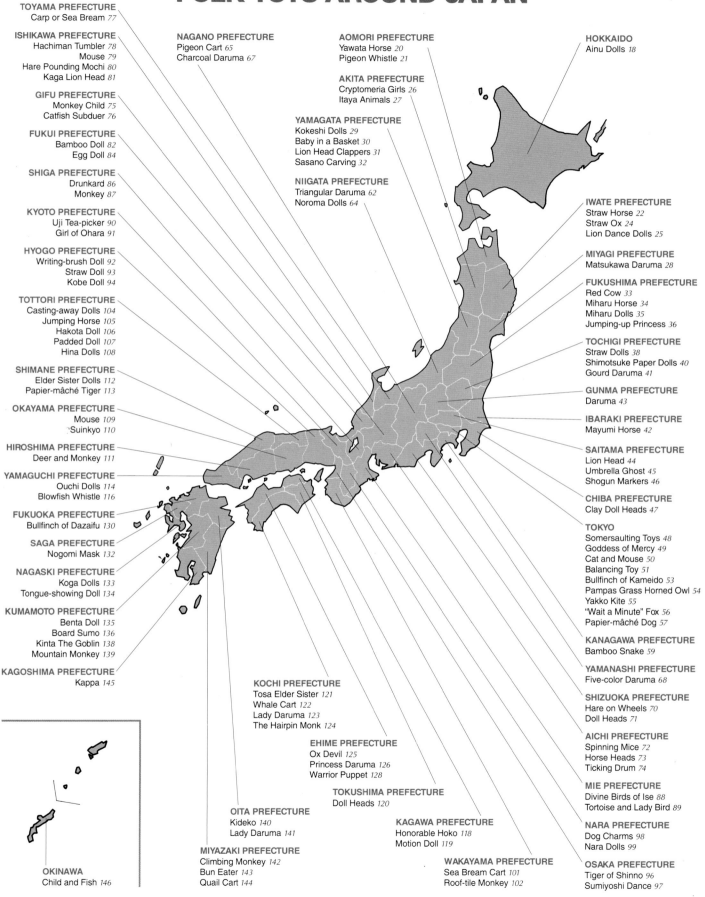

TOYAMA PREFECTURE
Carp or Sea Bream *77*

ISHIKAWA PREFECTURE
Hachiman Tumbler *78*
Mouse *79*
Hare Pounding Mochi *80*
Kaga Lion Head *81*

GIFU PREFECTURE
Monkey Child *75*
Catfish Subduer *76*

FUKUI PREFECTURE
Bamboo Doll *82*
Egg Doll *84*

SHIGA PREFECTURE
Drunkard *86*
Monkey *87*

KYOTO PREFECTURE
Uji Tea-picker *90*
Girl of Ohara *91*

HYOGO PREFECTURE
Writing-brush Doll *92*
Straw Doll *93*
Kobe Doll *94*

TOTTORI PREFECTURE
Casting-away Dolls *104*
Jumping Horse *105*
Hakota Doll *106*
Padded Doll *107*
Hina Dolls *108*

SHIMANE PREFECTURE
Elder Sister Dolls *112*
Papier-mâché Tiger *113*

OKAYAMA PREFECTURE
Mouse *109*
'Suinkyo *110*

HIROSHIMA PREFECTURE
Deer and Monkey *111*

YAMAGUCHI PREFECTURE
Ouchi Dolls *114*
Blowfish Whistle *116*

FUKUOKA PREFECTURE
Bullfinch of Dazaifu *130*

SAGA PREFECTURE
Nogomi Mask *132*

NAGASKI PREFECTURE
Koga Dolls *133*
Tongue-showing Doll *134*

KUMAMOTO PREFECTURE
Benta Doll *135*
Board Sumo *136*
Kinta The Goblin *138*
Mountain Monkey *139*

KAGOSHIMA PREFECTURE
Kappa *145*

OKINAWA
Child and Fish *146*

NAGANO PREFECTURE
Pigeon Cart *65*
Charcoal Daruma *67*

KOCHI PREFECTURE
Tosa Elder Sister *121*
Whale Cart *122*
Lady Daruma *123*
The Hairpin Monk *124*

EHIME PREFECTURE
Ox Devil *125*
Princess Daruma *126*
Warrior Puppet *128*

TOKUSHIMA PREFECTURE
Doll Heads *120*

OITA PREFECTURE
Kideko *140*
Lady Daruma *141*

MIYAZAKI PREFECTURE
Climbing Monkey *142*
Bun Eater *143*
Quail Cart *144*

AOMORI PREFECTURE
Yawata Horse *20*
Pigeon Whistle *21*

AKITA PREFECTURE
Cryptomeria Girls *26*
Itaya Animals *27*

YAMAGATA PREFECTURE
Kokeshi Dolls *29*
Baby in a Basket *30*
Lion Head Clappers *31*
Sasano Carving *32*

NIIGATA PREFECTURE
Triangular Daruma *62*
Noroma Dolls *64*

KAGAWA PREFECTURE
Honorable Hoko *118*
Motion Doll *119*

WAKAYAMA PREFECTURE
Sea Bream Cart *101*
Roof-tile Monkey *102*

HOKKAIDO
Ainu Dolls *18*

IWATE PREFECTURE
Straw Horse *22*
Straw Ox *24*
Lion Dance Dolls *25*

MIYAGI PREFECTURE
Matsukawa Daruma *28*

FUKUSHIMA PREFECTURE
Red Cow *33*
Miharu Horse *34*
Miharu Dolls *35*
Jumping-up Princess *36*

TOCHIGI PREFECTURE
Straw Dolls *38*
Shimotsuke Paper Dolls *40*
Gourd Daruma *41*

GUNMA PREFECTURE
Daruma *43*

IBARAKI PREFECTURE
Mayumi Horse *42*

SAITAMA PREFECTURE
Lion Head *44*
Umbrella Ghost *45*
Shogun Markers *46*

CHIBA PREFECTURE
Clay Doll Heads *47*

TOKYO
Somersaulting Toys *48*
Goddess of Mercy *49*
Cat and Mouse *50*
Balancing Toy *51*
Bullfinch of Kameido *53*
Pampas Grass Horned Owl *54*
Yakko Kite *55*
"Wait a Minute" Fox *56*
Papier-mâché Dog *57*

KANAGAWA PREFECTURE
Bamboo Snake *59*

YAMANASHI PREFECTURE
Five-color Daruma *68*

SHIZUOKA PREFECTURE
Hare on Wheels *70*
Doll Heads *71*

AICHI PREFECTURE
Spinning Mice *72*
Horse Heads *73*
Ticking Drum *74*

MIE PREFECTURE
Divine Birds of Ise *88*
Tortoise and Lady Bird *89*

NARA PREFECTURE
Dog Charms *98*
Nara Dolls *99*

OSAKA PREFECTURE
Tiger of Shinno *96*
Sumiyoshi Dance *97*

BIBLIOGRAPHY

ASTON, William G., Translator. *Nihongi. Chronicles of Japan.* Rutland, Vermont and Tokyo: Charles E. Tuttle, 1972.

BALL, Katherine M. *Decorative Motives of Oriental Art.* London: John Lane, The Bodley Head Ltd., New York: Dodd, Mead and Co., 1927.

BARBICAN ART GALLERY. *Karakuri Ningyo. An Exhibition of Ancient Festival Robots of Japan.* London: Japan Foundation, 1985.

BATEN, Lea. *Japanese Dolls: The Image and the Motif.* Tokyo: Shufunotomo Co., Ltd., 1986.

BATEN, Lea. *Japanese Animal Art: Antique and Contemporary.* Tokyo: Shufunotomo Co., Ltd., 1989.

CAIGER, G. *Dolls on Display.* Tokyo: Hokuseido Press, 1933.

CASAL, U. A. *The Five Sacred Festivals of Japan.* Monumenta Nipponica Monograph. Tokyo: Sophia University and Charles E. Tuttle, 1967.

CHAMBERLAIN, Basil H., Translator. *The Kojiki. Records of Ancient Matters.* Rutland, Vermont and Tokyo: Charles E. Tuttle, 1982.

CONDON, Camy and Kimiko Nagasawa. *Kites, Crackers and Craftsmen.* Tokyo: Shufunotomo Co., Ltd., 1974.

CULIN, Stewart. *Games of the Orient.* Rutland, Vermont and Tokyo: Charles E. Tuttle, 1958.

CZAJA, Michael. *Gods of Myth and Stone, Phallicism in Japanese Folk Religion.* New York and Tokyo: John Weatherhill, 1974.

DUNN, Charles J. *Everyday Life in Traditional Japan.* Rutland, Vermont and Tokyo: Charles E. Tuttle, 1972.

FOX, Carl. *The Doll.* New York: Harry N. Abrams, Inc., 1973. Reprint. Harrison House, 1988.

GRIBBIN, Jill and David. *Japanese Antique Dolls.* New York and Tokyo: John Weatherhill, 1984.

HEARN, Lafcadio. *Writings from Japan.* Edited by Francis King. Harmondsworth: Penguin Books Ltd., 1984.

HILLIER, Mary. *Automata and Mechanical Toys.* London: Jupiter Books Ltd., 1976. Reprint. London: Bloomsbury Books, 1988.

HORI, Ichiro. *Folk Religion in Japan.* Chicago and London: The University of Chicago Press, 1968.

HUIZINGA, Johan. *Homo Ludens. A Study of the Play-Element in Culture.* Boston: The Beacon Press, 1955.

JAPAN TRAVEL BUREAU. *Illustrated Festivals of Japan.* Tokyo: Japan Travel Bureau, Inc., 1985.

JOLY, Henri L. *Legend in Japanese Art.* London: John Lane, The Bodley Head Ltd., 1908. Reprint. Charles E. Tuttle, 1967.

KHANNA, Sudarshan. *Dynamic Folk Toys.* New Delhi Office of the Development Commissioner for Handicrafts, 1983.

KITAMURA, Tetsuro. *Nihon no Bijutsu: Ningyo, number 11.* (Arts of Japan: Dolls). Tokyo: Shibundo, 1967.

KYOTO NATIONAL MUSEUM. *Dolls of Kyoto.* Kyoto, 1970.

MASSY, Patricia. *Sketches of Japanese Crafts.* Tokyo: The Japan Times, Ltd., 1980.

McFARLAND, H. Neil. *Daruma: The Founder of Zen in Japanese Art and Popular Culture.* Tokyo and New York: Kodansha International Ltd., 1987.

MINGEI INTERNATIONAL MUSEUM OF WORLD ART. *First Collections: Dolls and Folk Toys of the World.* La Jolla, California: 1987.

MOES, Robert. *Mingei. Japanese Folk Art.* Brooklyn Museum Collection. New York: Universe Books, 1985.

MUSEE DES ARTS DECORATIFS. *Jouets traditionnels du Japon.* Paris, 1981.

MUSEES ROYAUX D'ART ET D'HISTOIRE. *Sur les traces de l'enfant.* Brussels, 1979.

NISHIZAWA, Tekiho. *Dolls of Japan/ Poupées japonaises.* Tokyo Kokusai Bunka Shinkokai, 1934. Printed for the International Exposition of Dolls in Antwerp, Belgium, November 1934.

OGAWA, Masataka. *The Enduring Crafts of Japan.* New York and Tokyo: John Weatherhill, 1963.

PIGGOTT, Juliet. *Japanese Mythology.* London: Paul Hamlyn, 1969.

SAINT-GILLES, Amaury. *Mingei. Japan's Enduring Folk Arts.* A. Saint-Gilles, 1983. First Tuttle edition, 1989.

SAITO, Ryosuke. *Nihon Ningyo Gangu Jiten.* (Dictionary of Japanese Dolls and Toys). Tokyo: Tokyodo Shuppan, 1968.

SHIKAMA, Tokio and Soshun Nakaya. *Kokeshi Jiten.* (Dictionary of Kokeshi). Tokyo: Tokyodo Shuppan, 1971.

SHISHIDO, Misako. *The Folk Toys of Japan.* Translator Tatsuo Shibata. Rutland, Vermont, and Tokyo: Japan Publications Trading Company, 1963.

SONOBE, Kiyoshi and Kazuya Sakamoto. *Japanese Toys. Playing with History.* Translator Charles A. Pomeroy. Tokyo: Bijutsu Shuppansha and Charles E. Tuttle, 1972.

SUWA, Shigeo and Shizuko. *Japanese Paper Dolls.* Tokyo: Shufunotomo Co., Ltd., 1976.

TAWARA, Yusako et al. *Nihon no Do Ningyo.* (Japanese Clay Dolls). Tokyo: Bunka Shuppan Kyoku, 1978.

TILAKASIRI, J. *The Puppet Theater of Asia.* Sri Lanka: Department of Cultural Affairs.

WEBER, Victor F. *Koji Hoten.* Paris: 1923. Reprint. New York: Hacker Art Books, 1965 and 1975.

YAMADA, Tokubei. *Nihon Ningyo Shi.* (History of Japanese Dolls). Tokyo: Fuzambo, 1942. Reprint. Tokyo: Kadokawa Shoten, 1961.

YAMADA, Tokubei. *Japanese Dolls.* Tourist Library, number 17. Tokyo: Japan Travel Bureau, 1955. Reprint 1959.

YANAGI, Soetsu. *The Unknown Craftsman.* Adapter, Bernard Leach. Tokyo and New York: Kodansha International Ltd., 1972.

YOSHIOKA, Sachio et al. *Japanese Folk Dolls and Toys.* Dolls of Japan and the World, vol.3. Kyoto: Kyoto Shoin Co., Ltd., 1986.

* * *

Mention must also be made of three extremely rare woodblock-printed documents which are artistic and antiquarian objects in their own right:

Edo Nishiki (Edo Brocade or Two colors of Edo) illustrated by Kitao Shigemasa. Dated 1773, the small book shows about 80 different toys and trinkets in color.

Ehon Seiro Bijin Awase (Picture Book Comparing Beauties of the Green Houses) illustrated by Suzuki Harunobu. Published in 1770 by Funaki Kanosuke of Suruga Street. The five volumes contain 166 color prints showing famous courtesans. Some are playing indoor games or holding various toys and dolls.

Karakuri Zue (Illustrated Compendium of Mechanical Designs) by Hosokawa Hanzo Yorinao. Dated 1796, the book has black and white drawings of a Japanese clock and nine ingenious mechanical toys with instructions for making them.

GLOSSARY

Ainu: aborigines, the oldest inhabitants of the Japanese archipelago, now living mostly in Hokkaido and nearly extinct; also known as Ezo and Yezo people.

battledore and shuttlecock: a typical New Year's game for girls, played with a rectangular wooden paddle used to strike a *hane*, a berry with implanted feathers. Some battledores are richly decorated with padded figures.

Boys' Day Festival: celebrated on the fifth day of the fifth month, now known as Children's' Day. Miniature weapons and doll figures of military heroes are exhibited.

bunraku: the most popular puppet theater of Japan, in which each puppet is manipulated by three men in full view of the audience. A narrator accompanied by a *shamisen* player tells the story.

Buddhism: an Indian religion which was introduced to Japan in 552.

daimyo: literally a "great name," a lord appointed by the shogun to govern a district.

daruma: a self-righting toy in the image of the Indian religious patriarch Bodhidharma.

dogu: oldest figurative statuettes known in Japanese history, dating from the neolithic Jomon period.

Doll Festival: also called Girls' Day Festival; celebrated on the third day of the third month, when dolls representing the imperial couple and their courtiers are exhibited.

dotaku: bronze bell-shaped artifacts found at excavation sites of the Yayoi period (250 BC to AD 250). Decorated with simple linear figures.

Edo: old name for modern Tokyo.

ema: literally "horse picture," a votive offering to a temple.

Ezo: old name for Ainu, both people and land (Hokkaido).

football: see *kemari*.

Genroku era: one of the richest and most fertile periods in Japanese art (1688-1704).

Girls' Day Festival: see Doll Festival.

Gosho doll: also known as Palace doll, represents a white-skinned, big-headed baby boy; typical present from Kyoto, the imperial capital.

hagoita and hane: the game of battledore and shuttlecock, see battledore.

handball: see *temari*.

haniwa: clay statuettes placed on and around the tombs of dignitaries during the Kofun period (AD 250-552).

hariko: a hollow papier-mâché figure.

Heiankyo: literally "citadel of peace and tranquillity," the name for Kyoto during the Heian period (794-1185).

hina: ancient name for doll, thought to derive from the Sanskrit word for "miniature representation."

hitogata: wood or paper cutouts in human shape; sold at temples and shrines, they were marked at the place of illness and pain, and then burned. Exorcism rites using *hitogata* of wood and bronze were

adopted from Chinese Taoism by Shintoism in the late seventh century.

byottoko: mask with a crooked mouth used in comical skits.

ichiboku-bori: carved from a single piece of wood.

inau: ritual implements of the Ainu people decorated with long, curling wood shavings.

inro: decorative compartmentalized medicine case carried by fashionable men; attached to the belt by a *netsuke* counterweight.

iomandé: an annual Ainu ceremony in which a bear was sacrificed.

ittobori: single-knife wooden carving; the object is shaped in simple, angular planes.

jizo: Bodhisattva or Buddhist saint, protector of children, travelers, and pregnant women.

junishi: the twelve animal signs of the oriental zodiac.

kabuki: popular theater of the Edo period, characterized by rich costumes, extravagant make-up, and female roles acted by men.

kami: gods present in all aspects of nature, a precept of Shintoism, the indigenous religion of Japan.

Kamo doll: a doll which originated at the Kamo Shrine of Kyoto; made from willow wood, it was dressed in the *kimekomi* manner: scraps of textile were pushed into deeply incised cuts of the body.

Kannon: the Buddhist goddess of mercy.

karakuri: trick doll, festival robot, mechanical doll performing all kinds of complex actions.

kasuri: a textile pattern woven with pre-dyed thread, usually blue and white.

katashiro: see *hitogata*.

kemari: seventh-century football game of Chinese origin, played with a stuffed leather ball.

netsuke: an artistically carved toggle, usually made from wood or ivory, used as counterweight to the *inro* case.

Nihon Shoki (Nihongi): "Chronicles of Japan," the second oldest and semi-legendary treatise of Japanese history (AD 720).

Nikko Toshogu Shrine: built 1617, the mausoleum of Tokugawa Ieyasu, the unifier of Japan and founder of the Tokugawa dynasty.

ningyo: usual name for dolls and small figurines generally, from the Chinese ideographs: *nin* =human, *gyo*=shape.

ninja: hired spies and assassins, usually depicted wearing black clothes and a hood.

noh: the classical theater of Japan, formerly reserved for the nobility. The actors wear beautiful brocade robes and carved wooden masks representing the features of men, women, gods and demons.

Oda Nobunaga: (1534-1582) great warlord and initiator of Japan's unification; assassinated by his general Akechi Mitsuhide.

omiyage: a present-souvenir, representative of a particular region.

Saga doll: a sophisticated wooden doll

made in Saga, a small town near Kyoto; gilded and lacquered, it shook its head and put out its tongue. Possibly made by carvers of Buddhist images.

Sambaso: an ancient ritual dance intended to appease the gods and bring good fortune. Performed at the beginning of the year, at the start of the kabuki season, and before certain noh plays.

shamisen: also *samisen*, a three-stringed musical instrument from the Ryukyu Islands, covered with snake or catskin and plucked with a wooden or ivory plectrum.

shibori: tie-and-dye, a textile technique in which the cloth is tied in certain places and dipped in dye, the tied part remaining uncolored.

Shintoism: the indigenous religion of Japan, advocating ancestor worship, ritual purity, and the gods of nature.

shogun: from the twelfth through the nineteenth century, the all-powerful military ruler of Japan.

Takeda doll: a doll made in the Kansai region (Kyoto-Osaka) characterized by a violent and exaggerated pose.

temari: embroidered or silk-thread balls used in girls' games.

Tokaido Road: the highway between Edo, the shogunal capital, and Kyoto, the imperial capital, comprising 53 stations or resting places.

Tokugawa Ieyasu: (1542-1616) the first Tokugawa shogun.

Tokugawa shoguns: the heirs to the office of military leader, the dynasty initiated by Tokugawa Ieyasu. The Tokugawa shogunate lasted from 1603 to 1867.

Toshogu Shrine: see Nikko Toshogu Shrine.

Toyotomi Hideyoshi: (1536-1598) a farmer's son, the "monkey-faced servant" of Oda Nobunaga, who took power on the death of his master and became the virtual ruler of Japan. One of the three unifiers of Japan.

twelve zodiac animals: (see also zodiac animals) the oriental zodiac has animals presiding over the twelve hours of day and night, as well as over a twelve-year cycle. The animals are the rat, the ox, the tiger, the rabbit, the dragon, the snake, the horse, the goat, the monkey, the rooster, the dog, the boar.

yabusame: a tournament proper to many festivals, when a mounted rider shoots arrows at a stationary target from his galloping horse.

yang: the active, positive, or male principle of the universe.

yin: the passive, negative, or female principle of the universe.

Yezo: see Ezo.

Yoshiwara: the pleasure quarter of old Edo, whose brothels were sometimes called Green Houses, because brothels in ancient China were painted green.

zazen: meditative exercises of Zen Buddhism.

Zen: an austere form of Buddhism, advocating meditation to achieve enlightenment.

zodiac animal: (see also twelve zodiac animals) a particular animal of the zodiac, one of the twelve zodiac animals.